The
STARVING
ARTIST
COOKBOOK

The
STARVING
ARTIST
COOKBOOK

ILLUSTRATED RECIPES FOR FIRST-TIME COOKS

SARA ZIN

The Countryman Press
A division of W. W. Norton & Company
Independent Publishers Since 1923

Book design by Endpaper Studio

For information about permission to reproduce selections from this book,
write to Permissions, The Countryman Press, 500 Fifth Avenue, New York, NY 10110

For information about special discounts for bulk purchases, please contact W. W. Norton
Special Sales at specialsales@wwnorton.com or 800-233-4830

Library of Congress Cataloging-in-Publication Data
Names: Zin, Sara, author.
Title: The Starving Artist cookbook : illustrated recipes for first-time cooks / Sara Zin.
Description: Woodstock, VT : Countryman Press, a division of W. W. Norton & Company,
[2016] | Includes index.
Identifiers: LCCN 2015041665 | ISBN 9781581573534 (hardcover)
Subjects: LCSH: Cooking. | LCGFT: Cookbooks.
Classification: LCC TX714 .Z56 2016 | DDC 641.5—dc23
LC record available at http://lccn.loc.gov/2015041665

The Countryman Press
www.countrymanpress.com

A division of W. W. Norton & Company, Inc.
500 Fifth Avenue, New York, NY 10110
www.wwnorton.com

978-1-58157-353-4

10 9 8 7 6 5 4 3 2 1

For my husband, Piotr Zin.
Thank you for your patience and love always,
but especially when I'm at my craziest.
And for sharing this strange and delicious
journey with me.

CONTENTS

INTRODUCTION

THE TRUTH IS THAT I'VE NEVER REALLY KNOWN WHAT TO DO WITH MY LIFE. I'VE HAD IDEAS about how to live—work tirelessly until I am successful (arbitrary)—and ideas about how not to live—just do nothing and see what happens (chaotic). But no matter what I do, it always comes back to my art. Weeks, months, even years can go by in utter confusion, but the moment I paint, I feel alive again, my vision clears, and whatever had been nagging me—fears about aging, the ever-present uncertainty of the future, and general doubts about who I am—begin to work themselves out. This happened, most recently, a few months back, when I picked up a paintbrush for the first time in over a year and painted the ugliest cookie I had ever seen.

It was terrible, like, wtf happened to my hand (or brain) to have diminished my once-honed ability? I stared, dumbfounded, at the awfulness, and it stared back, challenging me to do better. Asking me why I had stopped painting, and demanding that I wake up and get my life in order. I wasted the entire day looking at cookie images, analyzing how other artists painted food, worrying about what to do, and finding nothing that could help me. It was not something that I could force, or mimic, or control; I had to trust myself. Instinctively, I chose the tiniest brush I owned and went to work. Unsure of what would come, I painted over the entire cookie.

This was hard to do because the piece was a watercolor—to paint over it goes against all painterly common sense and technique. But I wasn't after tradition; I was aiming for whatever would make me feel better, even if, in the end I would throw it out and start all over again. I painted all night, and sometime during the process, I began to remember who I was, how much had changed, and why.

MY NAME IS SARA ZIN, and I'm an average "just turned 30" girl trying to make sense of a life gone unexpectedly off-plan. A few years ago, a dream of mine had been realized. I was living in New York City, working at a well-paying design company, and painting in every spare moment. Work-art, work-art, work-art, and all the while, the important things—food, sleep, love, life—had taken a back seat to my grand plan. I had everything mapped out:

"You put the time and effort in, the universe meets you the rest of the way, and that is how shit gets done." It had worked this way all my life—why would it ever change?

Except, as my husband Piotr and I drove our rented U-Haul across the Brooklyn Bridge and into our new neighborhood, Piotr—who had put his faith in my decision to sell our house in Seattle, drive across America, and live in the most crowded city in the United States (even though he hates large cities)—got a call from his dream employer asking if he was available to come to Los Angeles and work on a short-term project.

"Seriously?" I asked, incredulous. "We haven't even stepped onto the island! We spent five years in Seattle praying for such a call. It has to come now?!"

After the initial exasperation, we both agreed that he should take the job. It was only a short project, and then he'd come back and find a job in NYC. Once we found our new apartment and unloaded the truck, he returned to the West Coast, leaving me alone in that strange but holy city, to work and paint like the proud machine I had become. Needless to say, this interruption was not in my script, but a dream is still a dream, and I could check *Living in NYC* off life's "to-do" list. Next item—*Become a starving artist*. How hard could that be? Just don't eat. Piotr was the chef anyway—I never learned how to cook, having grown up with fast food and microwaveable dinners, too busy with my own interests to ever stay in the kitchen with my mother or grandmother.

As I settled into the city, I had more time than ever to paint. I was free to structure my days as I wanted—no husband to come home to, a comfortable job, and no friends to distract me. Only, I started noticing an emptiness building inside me. I couldn't understand what it was. I would come home from work, wrap my wrist for the nightly strain of holding a brush, paint until the early morning, and sleep a few hours before going to work again.

When I painted, I felt calm—this was exactly where I belonged. Free from my constant questioning and brutal self-recrimination. I felt allowed to experiment, to make mistakes. But somewhere between the validation I was receiving in the gallery world and my desire to be worthy, I lost my mind. I thought I wanted success, but really, I wanted people to love me. I looked around at the artists in the city, and felt that they were all going in a different, more correct direction than I was. These people had something to say, a mes-

sage, however beautiful or inarticulate or grotesque. But what did I have to say? How could I gain their love?

Work harder, mail this painting to that gallery, then start the next one. Apply for more shows. Send out my portfolio, go to galleries, go to museums, come back home and paint. Do it again. Life went on like this for a few months until I started to crumble like a stale cookie. I was exhausted, I was hungry, I didn't know what to paint—I'd lost any sense of a "message" inside me long ago. Piotr's project kept getting extended. One month apart became six months, then a year.

I asked myself over and over, *What do I have to say? What do I believe in?* But I loved only the act of painting. Couldn't art exist simply because it made me happy? Was that not worthy or meaningful? The only thing I had believed in was the plan, but that was breaking down. Was coming to NYC all a mistake? Had I uprooted my life, ruined the things that were working on some vague notion of how to be an artist? I had become a starving artist, as I had wanted . . . but not in the way I had wanted. I was literally starving, but for what?

I needed something sweet. I wanted my life to be like it was when my grandma would give me a cookie and hold me when I was scared. I stopped doing and started being, as memories flooded over me, past and present blurring together. I felt so lost. I wandered around the city and passed strangers, heard their excitement and hope, the kind I'd once oozed. But now, a cold sweat formed underneath all my layers of clothes, my toes numb from walking, my belly grumbling, my head spinning. As I opened my eyes to the dream I followed, everything became a question. *What does success even mean?*

The things I thought were solid—my art, my husband, my happiness—had disappeared. I had thought that life was fixed, that as long as I stayed within certain boundaries, nothing bad could happen, but that was a childhood naïveté. Adults had set those boundaries, but as an adult, an equal, life was boundless. I had made a mess of my life. How could I go back?

I returned to the West Coast, only to LA, not Seattle. Piotr had done brilliantly at his job and had been hired full-time. I, on the other hand, was unable to accept responsibility for my disappointments. I felt betrayed by my dreams, and locked my oil paints and canvases away. I sought to eradicate my art and chose to do the opposite of what I had done so far—focus on my body. Finally, I slept. I ate food that came from farms, not factories. I washed and brushed my hair regularly.

For the next year or so, I cooked. I had been picking up skills and ideas randomly over the years, watching friends, Piotr, and his family make dinner. I had always been an observer, witnessing the ease with which they created something so fundamental, so essential, so human. I wanted to tap into that humanity, so I took to the Internet and watched

cooking demos on YouTube, read food blogs and magazines, looked at step-by-step photo recipes, and started experimenting. I wanted to know things like what herbs to use in a soup, or how to brown chicken, or how to cook beef without turning it into flavorless rubber.

But, the idea of "from scratch" was still completely foreign to me. Like, with flour and eggs? How Grandma cooked? It felt ancient and time-consuming and, worst of all, hard. But what else did I have to do with the rest of my life? I had to eat every day, so why not start with the basics, from the beginning?

I asked family and friends for recipes, absorbed the Internet's endless foodie wisdom, and tried to cook what I thought would taste good and be healthy, from the simplest of ingredients. No prepackaged, premade, half-cooked anything. As I turned to food, I realized something important about myself—I felt better when I took care of my body! No high art full of archaic meanings or lofty, supercilious plan required. Sleep, mild exercise, good nutrition, and being around the people I love, every day. That was what I needed to be happy—to be successful.

I felt connected to my body for the first time in my life. Able to discern between my real emotions and the fluctuating sugary-ups and boozy-downs that resulted from a lifetime of bad habits. I noticed how things like drinking water, taking vitamins, and being outside in the sunlight had an immediate effect on my mood. I realized that my insatiable desire to be loved stemmed from my own self-hatred. All along, it seemed I'd been looking for compassion, respect, and love from myself, which came simply from taking care of my basic needs.

Food also allowed me to reconnect with my husband. I made three meals, for two people, every day. Beyond the meals, Piotr really loves sweets. I would bake oatmeal cookies for him once a month, and he'd bring them to work to share with his coworkers. I soon became known as "the cookie lady," and would bring them wherever I went.

In fact, I packed a large Ziploc bag of homemade cookies in my carry-on during our summer vacation that year. We had planned on driving from Germany to Italy, and would visit Piotr's Austrian friends en-route. Somewhere between the plane and the car, however, the cookies disintegrated into a bag of crumbs.

I had wanted those cookies to communicate my gratitude and friendship to people I had never met and would be imposing on. But fortunately, my hosts presented us with a large, traditional, homemade dinner upon our arrival, which helped fill my mouth and ease my awkward silence. Suddenly, that famed lightbulb lit up above my head: Food connects people, regardless of age, race, gender, even language. So I gave the bag of crumbles to my new friends, believing it was the thought that counted, and hoped the food would speak the words I couldn't say.

We met Piotr's family in Italy and explored the coast, swam in the Mediterranean Sea,

and ate a ton of shellfish. The entire vacation was a series of small epiphanies, all regarding family, relationships, and what it means to share a meal. To this day, I cannot eat Spaghetti alle Vongole without seeing my mother and sister's laughing faces, and remembering the sun-filled, salty smell of Sardinia's coastline.

I returned home feeling refreshed and whole. Life wasn't heavy if I didn't make it so, and though I hadn't consciously figured everything out, I stopped thinking that I needed to. Time moved on. I continued to cook, and surprisingly, my Austrian friends emailed me to ask for the recipe of the cookie crumble that I had made for them. At last, I was the one to impart baking knowledge!

Soon, summer became winter, Christmas rolled in, and I thought back to that recipe exchange and the enlightening trip that had connected us with our family and friends. Piotr and I wanted to use our skills to create something personal and unique. After much deliberation, we planned to make an illustrated cookbook of all the recipes we shared together on the trip, and many new ones that I had made during the year.

As usual, things didn't go as planned. That first cookie painting was truly unfixable, but it brought me back to my process and the simple joy of painting. As I worked on each illustration, I finally came to understand that there is no right or wrong way to be an artist. It wasn't art that had betrayed me, but the fixed ideas I had about myself, and a lonely, unhealthy, self-imposed lifestyle that had brought me to such a dark place. Art can be whatever I want it to be, I realized, and finally, I had something that I wanted to say.

As I look back in semi-bewilderment at those painful, transitional years, I feel fortunate that I chose cooking as a way to find balance in my life. So much has changed, and while I have always secretly wanted to be a consistent person, unswayed by the currents of life, I'm grateful that I'm not the person I used to be. It is my sincere hope that my journey through art and food will provide you with inspiration and nourishment. This cookbook includes the best recipes I made during that year of waiting, alongside the watercolor paintings that allowed me to connect to my art again. I can finally take care of myself and cook some damn good food. Hopefully you will too.

Cheers,

Sara Zin

Sara Zin

WHERE I BEGAN

WHEN I BEGAN MY COOKING JOURNEY, I HAD NO IDEA WHERE TO START. WHILE I WASN'T completely lost in the kitchen, my default meal was Creamy Chicken Ramen. Most people either learned how to cook as a child or, like me, had to do some serious ketchup. Enter the good ol' Internet. Except, as I started searching, I immediately felt overwhelmed by the endless amount of information on how/what to cook. Who could I trust? And how could I start from a simple—but solid—place?

This is the cookbook that I longed to find back then—a beginner's manual with a kick. Although I don't pretend to know everything about cooking, I've put what I do know in a condensed and easily digestible format that doesn't require any Internet connection or a French dictionary.

I wrote and organized this cookbook in the way I actually learned how to cook. The Basics section contains a general overview of techniques, equipment, ingredients, and food storage, without which learning to cook would be costly and wasteful. The recipe sections are divided into the themes that I search for when looking for a recipe: breakfast, salads, sandwiches, soups, etc. And within those categories, there is a range of recipes with distinctly different taste offerings, to help you define your palette and learn the methods that are fundamental to gaining that much-desired acuity.

I chose each meal using as many different, fundamental ingredients as possible—vegetables, poultry, meat, fish—without using specialty ingredients, which can be expensive and hard to find. Some recipes include shortcuts with time-saving helpers, like bouillon cubes or frozen pie dough, so you can adjust cooking time to fit within your lifestyle. While I aim to cook from scratch, I'm not against premade foods. I just don't recommend chemically harmful ingredients that can be sneaky and hard to recognize.

Furthermore, all the sections have a short personal story, sharing whatever memory these flavors stir up, and a few hard-won food tips sprinkled within. These recipes were the medicine that I used to heal my body, educate my mind, and find out what I love. I continue to cook them regularly and hope you'll join me.

THE BASICS

THERE ARE ONLY SO MANY WAYS TO COOK FOOD—THANK GOODNESS FOR SMALL MIRACLES! But there are four main areas of cooking to be aware of before heading into the kitchen: 1—Technique, 2—Equipment, 3—Ingredients, and 4—Food Storage. Master these and hopefully you won't ruin nearly as many pots and pans as I have.

TECHNIQUES

Boiling: Water boils at 212 °F in the USA and 100 °C in the rest of the world. You fill a pot with water and turn the heat on high until you start seeing large bubbles, and that's it. This method can be used to cook just about anything.

Simmering: Many recipes call for you to boil a mixture and then "reduce it to a simmer," which means to bring the temperature below boiling point, anywhere from 140–190°F/ 60–87°C. The general surface activity will be reduced—just think smaller bubbles. This method can also be used to cook just about everything.

Steaming: You can steam food either in a pressure cooker or a rice cooker (with an attachment for steamed vegetables), or by bringing a small amount of water to boil. Place a colander above the pot so the steam can reach the food, cover, and reduce the heat to medium until cooked. This method is used to cook a wide variety of foods, such as vegetables and pot stickers.

Toasting: This word can mean a lot of things, from toasting chestnuts by the fire to making a crispy bagel. In this cookbook, I refer mainly to bread products. You can toast something by using a toaster, toaster oven, or the broiler (that bottom drawer in gas ovens). To toast using the broiler, turn the oven on to broil, then place your food in the drawer and close. If you're lucky and own a fancy electric oven, press the broil button. Keep an eye on it because it will brown very quickly.

Frying/Sautéing: This is the most important method to master, since it is one of the quickest and easiest ways to cook. Heat a small amount of butter, fat, or oil in a pan, to

prevent sticking and to add flavor, and cook whatever you want over the heat. If you would like to brown meat, be sure to add just enough oil to lightly coat the bottom, and heat the pan on high (make sure it's smoking), before you add the meat. For sautéing, you typically cook over medium or low heat, adding foods as you go and tossing or stirring them to keep the freshness (you may also need to add a few splashes of water so the food doesn't burn). And frying is anywhere in between those heat levels.

Blanching: This method is used to partially cook foods, either to prepare for freezing, to gently cook vegetables while keeping their vibrant colors and flavors, or to help loosen the skins on fruits or vegetables for peeling. Bring a pot of water to a boil, dip or add the food for only a few minutes (or less), then remove quickly and place in a large pot of ice water to stop the cooking process.

Poaching: A method similar to blanching, poaching means you cook in simmering water (just under the boiling temperature), and you don't remove the food so quickly. Bring a pot of water to a low simmer (only a few small bubbles) and fully submerge the food. This method is best for eggs, fish, and some vegetables.

Roasting: This technique cooks food using the dry-heat from an oven, and is very easy because you can cook large meals without making too much of a mess. Just butter or oil up whatever meat or vegetables you are cooking, and place the food in the oven until cooked. Temperature-wise, there are a variety of different techniques, from low heat (200 °F/93 °C or higher) to high heat (500 °F/260 °C or lower), or a combination of both ranges. This method is great for large, tender cuts of meat or root vegetables.

Braising: This method is used to cook tougher, more affordable cuts of meat, using both dry and moist heat (think slow cooker, or those beautiful Dutch ovens). To begin, you sear the meat over very high heat, then transfer to a pot with vegetables (optional) and some liquid (to prevent burning) and cook covered over low heat for a long period of time.

Baking: This is basically the same as roasting, only it's used more generally to include sweets, breads, etc.

Broiling: This technique cooks food with very high heat for a short period of time. There are two methods: one uses the broil setting on an electric oven or the drawer under a gas oven, and the other uses the stove top over very high, dry heat. This creates grill-like results or is used to brown or cook meat very quickly.

Grilling: Requires a gas, charcoal, or electric grill. It typically cooks food over high heat or a flame over a grill—hence the name.

Deep-Frying: This method of cooking submerges food in hot fat. If you don't have a deep fryer, you can take a large pot or deep pan and fill it with oil (canola, peanut, soybean, sunflower) or lard, and heat the oil to 375 °F/190 °C, which is very hot, so be extremely careful. Then you submerge your food for a very brief amount of time, remove it, and let it dry on paper towels to absorb the excess fat. Never add water to hot oil—it will instantly turn to steam and explode!

EQUIPMENT

Pots & Pans: Yep, you're going to need these. Hopefully you have inherited some from your parents, or found some left behind from roommates, because they can get expensive and it's good to have a range of sizes. I recommend having at least the following:

- 2-inch saucepan with lid
- 4-inch saucepan with lid
- 8- to 9-inch skillet with lid
- 12-inch deep-sided skillet with lid
- 4- to 6-quart Dutch oven or heavy-duty pot with lid
- 12-quart (or larger) stockpot with lid

If you've decided to make an investment and buy or upgrade your cookware, there are many aspects to consider when choosing, such as heat conductivity (material), price, maintenance, and health benefits. Unfortunately, each of these qualities have pros and cons, so there is no clear winner. The best heat conductor is copper, but it is expensive, reacts with acidic foods, and requires polishing and regular maintenance. Aluminum is the next best heat conductor and is very common, making it cheap, but it also reacts with acidic foods and scratches and dents easily. Cast iron is a good conductor, cheap and traditional, but is high-maintenance. And there is stainless steel, which is relatively cheap, doesn't react with foods, doesn't require maintenance, and is durable, but doesn't retain heat as well as the others.

The health factor applies in regards to nonstick or improved heat-conducting coatings. These coatings may use chemicals or processes that have been linked to health hazards. The safer materials are cast iron, stainless steel, and stoneware. It's all a matter of preference, cost, and belief systems, so choose the material best suited for you.

Baking Dishes: You're also going to need some bakeware if you want to make some of the recipes in this book. And again, there are a variety of materials to choose from, such as metal, glass, ceramic, stoneware, and silicone. Metal bakeware is cheap and common, but can rust. Glass takes a while to heat up, but it provides a longer, even temperature—however, it can crack if the temperature changes too quickly. Ceramic and stoneware materials are durable and evenly distribute heat but can be expensive. Silicone has become increasingly popular since it is non-stick, lightweight, and dishwasher-safe. For starters, you should buy one piece at a time as you need each one, and try a few different options before deciding on a set. Here is a list of the basics that you'll need:

- A cookie sheet/baking sheet (12 x 17-inch or 14 x 17-inch)
- A deep baking dish/roasting pan/casserole dish (9 x 13-inch)
- A medium-size loaf pan (8 x 4-inch)
- A 9-inch springform pan
- A muffin tin
- A pie pan

Cooking/Baking Utensils:
- colander
- skimmer
- whisks
- spatulas (rubber or wooden)
- large stirring spoons
- ladle
- metal grater
- tongs
- vegetable peeler
- measuring cups and spoons
- meat thermometer
- rotary cheese grater
- large scissors

- 3-inch paring knife
- 6- to 8-inch chef's knife
- 8-inch bread knife
- honing steel/knife sharpener
- electric hand mixer/stand mixer
- blender
- servingware
- silverware
- Tupperware

INGREDIENTS

Choosing ingredients from the abundance at the grocery store can be a challenge. For me, it's important to eat organic, free-range, non-additive foods, but labels can be deceiving and quality is expensive. The only way I've found to be budget-conscious and healthy is to create a list of what I need beforehand and buy as many items in bulk as I can. (Oh, and I eat before going to the grocery store, so I won't buy needlessly.) This is how I organize my shopping list. I always maintain a stock of the following:

- **In My Fridge:** butter, cream cheese, sour cream/heavy cream, Greek yogurt, active dry yeast, miso paste, apple cider vinegar, rice vinegar, rice wine, capers, pickles, hoisin sauce, Worcestershire sauce, soy sauce, oyster sauce, fresh herbs, various other condiments, creamer, wine, and beer.

- **On My Counter:** onions, garlic, bananas, tomatoes, and bread.

- **In My Pantry:** extra-virgin olive oil, canola oil, sesame oil, balsamic vinegar, white vinegar, honey, sugar, brown sugar, wheat/white/bread flour, confectioners' sugar, cornstarch, baking powder, baking soda, salt, pepper, dried herbs, toasted sesame seeds, quinoa, couscous, brown rice, pasta and grains of various styles, beans, crackers, various nuts, steel-cut oats, baking chocolate chips, emergency canned foods (such as soups, corn, beans), bread crumbs, chicken/beef/vegetable bouillon cubes, tomato paste, canned peeled tomatoes, coffee, various teas, marsala wine.

FOOD STORAGE

One of the biggest hurdles I've overcome as I've learned how to cook is learning how to properly store food. Since I try to buy as much as I can for the week in as few trips to the grocery store as possible, I've had to throw out a lot of rotten, fuzzy, gross foods and then felt terribly guilty about my wastefulness—so much so that I often avoided buying fresh fruits and vegetables out of fear of turning something over to find a grotesque mess. But living in fear of my own stupidity is no way to live, so here are a few pointers to help you avoid this situation.

- **In the Fridge:** all meat, fish, eggs, dairy, and most cheeses. Be sure to keep them in their original wrappings. If the packages leak, place them in a Tupperware or plastic bag. Also, it's good to note that plastic or glass containers for milk are better since cardboard can grow mold. Store cheeses in wax paper or loose plastic wrap once opened.

 All vegetables and fruits (except the ones mentioned below, which I keep on the counter), fresh herbs, ginger, and any vegetables or fruits that have been halved (for example: avocados, bananas, citrus). Be sure to keep vegetables and fruits with similar vegetables and fruits, since they give off different gases—apples to apples, root vegetables to root vegetables. And don't wash them before placing them in the refrigerator unless they go into the fridge completely dry, since this can create dampness and mold. Mushrooms can be stored in a paper bag. Bread, cakes, and pies can also be stored in the fridge if you want them to last longer.

- **On the Counter:** Note that these items must be stored in a cool, dry place, out of direct sunlight. Alliums (garlic, onions, shallots), tomatoes, avocados (to ripen), bananas, melons, fresh bread, cakes, and pies.

- **In the Pantry:** Everything else.

BREAKFAST

THE FIRST THING I DID WHEN I LEFT THE BIG APPLE FOR THE GOLDEN STATE WAS SLEEP. I slept like it was my job and also my hobby. I was so damn tired, and since I had no plan for what came next, sleep was the only thing that made sense. I had come to an ending; I could not go forward as I had been—I had to change. I wrapped myself in a chrysalis of blankets and transformed.

As I rested, time lost all meaning; the days blurred together, dreaming and waking becoming indistinguishable. It was wonderful and scary and dangerous. I remember lying in bed, staring at the ceiling, thinking *Why get up?* for the hundredth time. Healing could turn into depression at any moment; I needed to answer that question.

In the meantime . . . coffee! Even with all the sleep I could want, I still wanted coffee. That's why I had gotten up all those other days. Habit or addiction? Who cares? Piotr would come home for lunch and we'd go out or have eggs. Might as well put the pot on.

Side note: Answers don't always come like a brick to the head. Sometimes you're staring right at them. At that time, for two months I bitched about why I didn't have a reason to get up, feeling like a loser, cursing the world for abandoning me . . . while at the same time, I woke each morning secretly looking forward to cooking breakfast.

I knew how to make eggs. Maybe not the right way, but come on, you crack it over some heat and it's done. I'm not that stupid. But just as a curiosity, I wanted to know, *Is there a right way to make scrambled eggs?*

The answer is no, it's all personal preference—though I'm sure someone will have something to say about this assertion. However, I did learn that I was overcooking my eggs, if I wanted a good scramble. My preferred version is soft, slightly wet, but definitely not the polenta-like fancy version. I crack 2 eggs in a cup, add a pinch of salt, and whisk them with a fork for 30 seconds. Then I heat a small pan over medium-low heat , melt 1 tablespoon butter, and add the eggs. You can also add milk or cream during the whisking process, but it would be less eggy, so I don't. Using a spatula, stir the eggs until small curds form, then remove right before they're fully cooked. (They will continue cooking from their own heat.) I eat them with a good dollop of ketchup and dry toast, or jelly and toast. Please don't judge.

After exhausting the scrambled egg theme, what else could I make? Each day was an experiment. I tried various boiled egg times, poached, slow-cooked, even steamed eggs. I made some awful-looking, delicious-tasting omelets, finding what vegetables and spices go well together. Fresh dill, capers, and crème fraîche go fantastically well with eggs, whether they're mixed in, added on or around the eggs, or used individually.

My favorite breakfast dish was a piece of toast with half an avocado, cut or mashed, and a simple over-medium egg on top. Maybe some freshly ground salt and pepper and a cup of coffee. Another keeper was learning how easy it is to make deviled eggs—hard-boil an egg, slice it in half, remove the yolk, and mix it with some mayo, mustard, or a bit of horseradish (if you like spicy). Sprinkle in some salt and pepper and spoon the yolk mixture back into the white of the egg. Or, if you want to be fancy, place it in a Ziploc bag, cut the tip of one corner, and squeeze the yolk mixture out in patterns.

Brunch quickly became my thing—we ate bigger and bigger meals, and my habit of eating a large, heavy, late dinner or over-snacking at night became a thing of the past. I found myself waking up naturally, without an alarm, and not being able to go back to sleep! I had all this energy; I didn't want to sleep anymore.

I had always thought I was a night owl, and yet here I was waking at the break of dawn, like a lark—what was going on? Did the cocoon thing really work? Scientifically, I have no idea why, but my gut says that digestion has a lot to do with it. Whenever you eat your biggest meal is when you'll have the most energy. Eating breakfast or at least a big brunch gives you energy during the day, so you can run around and be tired when night comes around. Hmm (steepled fingers) . . . interesting.

So, yeah, that's what happened. I finally found a reason to get up and do something with my day. We ate a lot of eggs and experimented with many alternatives—some more challenging and interesting than others—and eventually settled on a contented routine consisting mainly of these recipes.

MORNING THOUGHTS

I HAVE ALWAYS HAD A DEEP, ALMOST ROMANTIC LOVE FOR BREAKFAST. AFTER DRINKING THE mandatory morning coffee, I would already be in the kitchen, so I figured I might as well make breakfast. Which led to the question . . .

WHAT'S IN THE KITCHEN?
In a perfect world, these are the ingredients I would always have on hand, and they would be all you needed to make the following recipes. I leave some items open to be personalized, such as cheese and protein preference, but if you have these ingredients, you're all set.

- fresh eggs!!!
- a very good butter (salted or unsalted, but not in a tub) (make sure it really is butter by reading the label)
- spinach, kale, avocado, peppers, mushrooms
- onions, garlic, and tomatoes (kept on the counter, not in the fridge)
- milk, heavy cream
- cheese, bacon, sausage, tofu, smoked salmon, ham
- bread or bread-like substance (English muffin, corn tortillas, etc.), quinoa, or your grain of preference
- flour, sugar, baking soda, baking powder, confectioners' sugar
- fresh fruit (especially lemons)
- honey, maple syrup, olive oil, canola oil, rice vinegar
- salt, pepper, cinnamon, vanilla extract

INTERNATIONAL HOUSE OF BREAKFAST
When I was young, my mom would make me scrambled eggs with toast and/or cereal for breakfast, or I'd get a breakfast sandwich to go if I was late and missed the bus. In high school and college, I upgraded to IHOP (International House of Pancakes), a chain of then-local diners, for my brunches, but it wasn't until I traveled to other countries that I realized how different breakfast is in every culture.

Experiencing other cultural norms completely changed my perception of food. In Piotr's hometown of Krakow, Poland, the morning meal isn't that big a deal. Mostly pastries and coffee, sometimes sandwiches and coffee, or else just coffee. In mainland Italy, it's the best cappuccino of your life and a croissant or pastry. In Sardinia, off the coast of Italy, it's almond cakes, yogurts, fruits, and cheese.

In Germany it's bread rolls called Brötchen and butter or jam, cold cuts, and soft-boiled eggs. In Greece, it's a cigarette and coffee, or tiganites, these amazing mini-pancakes soaked in honey. In Korea, it's soup, rice, and kimchi, or a really delicious scrambled egg with jam sandwich that my sister-in-law made for me (but that may not be traditional). In Singapore it's kaya toast and soft, almost liquid, boiled eggs. In Japan, it's miso soup, fish, rice, and seaweed. There are so many different ways to enjoy the first meal of the day.

TYPES OF PORRIDGE

Porridge is, by definition, any grain, cereal, or legume that is boiled in water, milk, or both, and served hot. It can be made from rice, corn, quinoa, oats, etc., and every culture has its own take on this healthy breakfast option. Here are just a few of the common types.

Rice Porridge: a.k.a. congee or *juk.* You take rice and cook it in a liquid until it reaches a soupy consistency. Bring 6 cups water + ½ cup uncooked short-grain rice to a boil, then reduce to a simmer. Cover, stir occasionally, and cook for 1 to 1½ hours. This will create a very bland porridge, but you can make it sweet or savory by using milk or stock instead of water, and/or by adding meat, eggs, vegetables, and seasonings.

Grits: These are coarsely ground white or yellow corn kernels, boiled in water or milk. For a savory version, bring 1 cup water + ¼ cup grits, ½ tablespoon butter, and a pinch of salt to a boil, then reduce to a simmer. Cover, stir occasionally, and cook for 20 minutes. For a sweet version, bring 1 cup milk + ¼ cup grits, ½ tablespoon honey, and a pinch of salt to a boil, then reduce to a simmer. Cover, stir occasionally, and cook for 30 minutes. Quick-cooking grits are also commercially available.

Quinoa Porridge: This is quinoa cooked in water or milk. Thoroughly rinse the quinoa. Bring ½ cup of quinoa + 1½ cups of milk to a simmer. Cover, stir occasionally, and cook

for 10 minutes. Add 1 tablespoon of brown sugar and a pinch of cinnamon, stir, then continue to simmer for 15 minutes. Serve with milk and fruits/nuts. You can substitute almond or soy milk here, too.

OATMEAL AND THE LIKE

Oatmeal is a type of porridge made by processing oats, but there are a lot of different varieties to consider. To begin with, let's talk about groats, which are the whole oat berries without their hulls (the hulls are inedible). A groat looks like a seed and includes the bran and germ, making it rich in fiber and nutrients. It takes the longest to cook and needs to be soaked for at least one hour, but preferably overnight, before being cooked and made into oatmeal. The most common oatmeal options are:

Steel-cut Oats: Chopped whole groats.
Simmer 3 parts water:1 part oats for 20 to 30 minutes.

Scottish Oats: Stone-ground groats.
Simmer 3 parts water:1 part oats for 10 minutes.

Rolled Oats: a.k.a. "old-fashioned oats." These are steamed and flattened (rolled) groats, which are then dehydrated.
Simmer 2 parts water:1 part oats for 10 minutes.

Quick Oats: Rolled oats that are chopped before dehydrating and/or steamed longer.
Simmer 2 parts water:1 part oats for 3 to 5 minutes.

Instant Oatmeal: Quick oats that are rolled and steamed for an even longer period of time.
Add ½ cup boiling water to ⅓ cup instant oatmeal and stir.

Oat Bran: The outer coating of a groat, which is mostly fiber—it's a byproduct of making oatmeal. Used as an additive or can be made into a porridge like Cream of Wheat.
Slowly add ⅔ cup oat bran to 2 cups of boiling water and cook for 2 minutes.

SIMPLE EGGS

I SHALL BEGIN WITH THE MOST AMAZING AND PERFECT INGREDIENT—EGGS. NOT ONLY ARE they delicious, easy, and quick, but they are as fundamental to cooking as water and salt, which is—ironically—all you need to cook them. Well, that and maybe a little pepper. The difference between a good egg and a great egg, however, is its freshness.

All USDA-graded egg cartons include two different dates: The sell-by (or expiration) date and a three-digit number between 001 and 365 known as a Julian date, which indicates the exact day that carton was packaged. This number represents a consecutive day of the year (001 = January 1, 365 = December 31), and it is the best gauge of freshness.

Here are my tried-and-true methods for cooking eggs:

Boiled: Fill a pot with cold water so the eggs are fully submerged, and bring the water to a boil. Once the water starts to boil, set your timer for: 3 minutes exactly for 3-minute eggs (yolks are liquid but the whites are mostly firm); 4 minutes for soft-boiled eggs (yolks are runny with some firmness); 6 minutes for slightly firmer soft-boiled eggs (yolks are velvety); 15 minutes for fully hard-boiled eggs (yolks are solid and chalky). Once the allotted time is up, remove the eggs from the pot quickly and place them in cold water or under cold running water. This will help the shell come off without making an unappetizing mess.

Fried: I prefer to fry my eggs in olive oil (rather than butter) because I like them crispy. Heat 1 teaspoon olive oil over medium-high heat and gently crack an egg over the pan so the yolk remains intact. Olive oil typically has a higher smoke point than butter, so it may crackle—this is fine. Depending on how runny you want your eggs, act accordingly: For a sunny-side up egg, once the white has solidified, turn the heat as low as possible, cover with a lid, and cook for 1 minute. For an over-easy egg, follow the same steps but cook for 3 to 4 minutes. For an over-medium egg, wait until the white has fully formed, then quickly flip and fry the other side for 30 seconds. For a well-done fried egg, follow either method (with lid or flip) and cook until the yolks are solid.

Scrambled: For scrambled eggs, butter is better than olive oil because it adds flavor and creaminess. (Note: Use butter, not margarine, and preferably the best quality salted or unsalted that you can find.) In a bowl, whisk your eggs until everything is uniform in

color. Heat 1 tablespoon butter over low heat and, once the butter begins to foam, add the eggs. Using a rubber spatula or wooden spoon, gently stir or push the eggs until small curds form. For a delicate, ricotta-like texture, stir continuously over low heat until the eggs are set. For a more solid texture, raise the heat to medium and push the eggs around until they are firm. Season with salt and pepper.

Poached: It is essential that the eggs are as fresh as possible when poaching, so the whites are firm and tight to the yolk and will therefore hold their shape. Fill a 1½- to 2-inch-deep pan with water and bring to a simmer (small bubbles). Crack the egg into a shallow cup or bowl, making sure the yolk remains intact. Slowly add the egg to the simmering water. (Note: Adding a bit of vinegar to the water helps set the egg but does affect the taste.) Cook the egg for 1 to 2 minutes. Gently remove the egg with a slotted spoon or strainer and place on a paper towel to absorb any excess water. Trim the edges if so desired.

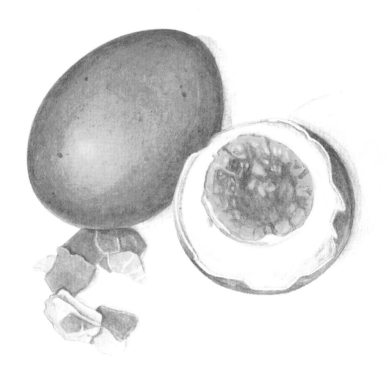

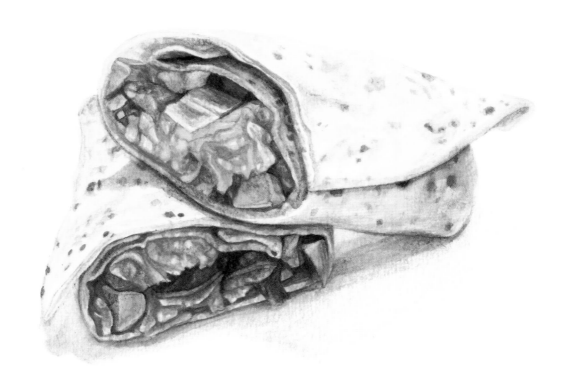

BURRITO SCRAMBLE

SERVES: 2

DIRECTIONS

1 Dice the red onion and jalapeño pepper.

2 In a bowl, whisk the eggs.

3 Heat a pan with a few drops of olive oil and sauté the peppers and onions until the onions are translucent.

4 Add the eggs to the pan and season them with salt and pepper. Using a spatula, stir until small curds form and the egg is cooked to your preference.

5 Heat the tortillas in a microwave or pan so they are flexible.

6 Cut up half an avocado.

7 Spoon the scramble and avocado into the center of the tortillas. Add your favorite hot sauce or salsa (optional). Fold two opposite sides of the tortilla inward, then roll it up. You can wrap the burrito in aluminum foil to help it keep its shape.

INGREDIENTS

¼ red onion

1 jalapeño pepper

2 eggs

extra-virgin olive oil

salt and pepper

2 flour tortillas

½ avocado

hot sauce/salsa (optional)

NOTE This is an essential SoCal breakfast to-go. It takes 1 minute more than your favorite scramble, and then you can eat it with one hand on your way to wherever you're going in the morning. This is another of those infinitely adaptable recipes, and it can be microwaved back to life as a midday snack.

PIOTR'S APPLE PANCAKES

SERVES: 4

DIRECTIONS

1 Core and peel the apple. Cut into ¼-inch slices horizontally, so the cored hole is in the center of each slice.

2 Combine the flour, baking powder, salt, cinnamon sugar, vanilla extract, eggs, and 1 cup of milk. Mix with an electric mixer or whisk thoroughly by hand. Keep adding milk, little by little, until the batter is thick enough to evenly coat the back of a spoon.

3 Heat butter and spread evenly on a large nonstick pan over medium-high heat. Wait until it's hot, but be careful not to burn the butter.

4 Pour about ¼ cup of batter onto the pan and place a slice of apple in the center, gently pushing it into the batter.

5 Flip once the bottom is browned, cooking the pancake for about 1 to 2 minutes on each side. Repeat until all the batter is used.

6 Serve with maple syrup and any leftover apple slices.

INGREDIENTS

1 apple

2 cups flour (250 grams)

2 tsp baking powder (8 grams)

¼ tsp salt (1 gram)

2-3 tsp cinnamon sugar (8–12 grams)

¼ tsp vanilla extract (1 ml)

2 eggs

1–2 cups milk (240-475 ml)

1 tbsp butter

maple syrup

NOTE This basic pancake batter is an essential recipe because it's cheap, easy, and super flexible. It can be made plain or with other filling options like pears, blueberries, raisins, nuts, etc. Or, if you're a savory kind of person, you can experiment with spinach and cheese fillings. (In that case, I would skip the syrup.)

VEGETABLE & SAUSAGE CRUSTLESS QUICHE

SERVES: 4

DIRECTIONS

1 Preheat the oven to 375 °F (190 °C).

2 Chop the sausage, mushrooms, and onion into small, similar-size pieces (so they will cook evenly), and slice the tomato.

3 Heat a pan with a few drops of olive oil and sauté the sausage, mushrooms, onions, and washed spinach until the onions are translucent. Remove from heat.

4 In a large bowl, whisk the eggs and season with a pinch of salt and pepper. Add the feta cheese, milk, and sautéed vegetables, then stir.

5 Pour this mixture into a pie pan and place the tomato slices on top.

6 Bake for 30 to 35 minutes, and let cool for 5 minutes.

INGREDIENTS

Leftover cooked sausage

5 button mushrooms

½ yellow onion

1 ripe tomato

extra-virgin olive oil

2 cups fresh spinach (450 grams)

6 fresh eggs

salt and pepper

½ cup feta cheese (75 grams)

¼ cup milk (60 ml)

NOTE This is a great dish to make for breakfast because it can last for a few days in the refrigerator and it gets better every time you reheat it. You can also substitute any other protein for the sausage—tofu, bacon, chicken leftovers, etc.—and kale or chard for the spinach.

FRENCH TOAST & CRISPY BACON

SERVES: 4

DIRECTIONS

1 Place 2 paper towels on a large plate and lay the bacon strips on top. Cover with 2 more paper towels and cook in a microwave on high for 2 minutes. Pat down, and then continue cooking in 30-second intervals until crispy.

2 Slice the chalka bread into thick slices.

3 In a large bowl, whisk the eggs, vanilla extract, cinnamon sugar, milk, and a pinch of baking powder.

4 Heat butter and spread evenly in a large nonstick pan over high heat.

5 Stir the batter so the cinnamon doesn't sink to the bottom right before you dip the bread in it. Coat the bread completely, then place in the pan and lower the heat to medium.

6 Cook until the bottom side is browned and flip to cook the other side (about 2 minutes). Repeat with all the slices.

7 Serve with maple syrup and raspberries.

INGREDIENTS

4 slices bacon

4 slices chalka bread

2 eggs

½ tsp vanilla extract

1 tsp cinnamon sugar (4 grams)

¼ cup milk (60 ml)

a pinch of baking powder

1–2 tbsps butter (14-28 grams)

maple syrup

raspberries (optional)

NOTE The key to this recipe is to use chalka (recipe on pg 218) or another thick, sweet bread that is at least a day old and slightly dry. This allows it to absorb the batter better, for a rich and eggy taste. I prefer to microwave my bacon to make it evenly crunchy and lower in fat. Plus, it saves me from having to clean one more pan.

GARLIC KALE & EGGS QUINOA

SERVES: 2

DIRECTIONS

1 In a small pot, combine quinoa with water and bring to a boil, then reduce to a simmer and cook covered for 10 minutes. Lightly fluff the quinoa using a fork, then let it rest.

2 Remove the stems from the kale and chop the leaves into small pieces or strips. Dice the red onion and mince the garlic cloves.

3 Heat a few drops of olive oil in a large pan and sauté the onions and kale over medium-high heat until the onions are translucent.

4 Add ½ cup of the cooked quinoa (or however much you want) and the minced garlic, drizzle a bit of olive oil on top, and stir. Season with salt and pepper, reduce the heat to medium-low, and cook for another 3 to 5 minutes.

5 In a separate pan, add a few teaspoons of olive oil and fry the eggs.

6 Serve the quinoa with the eggs on top and season with salt and pepper.

INGREDIENTS

½ cup quinoa (100 grams)

1 cup water (240 ml)

4 large kale leaves

¼ red onion

2 garlic cloves

extra-virgin olive oil

salt and pepper

2 eggs

NOTE You can't go wrong with kale and garlic. I like using dinosaur kale for sautéing because it has a velvety texture that goes well with quinoa and eggs. This is a very quick and easy recipe, and you can substitute spinach or chard for the kale. You can also add some mushrooms (sauté them with the onions and kale) for an earthier taste.

POPOVERS WITH STRAWBERRY BUTTER

SERVES: 10

INGREDIENTS

1 tbsp butter (14 grams)

2 eggs

1 cup milk (240 ml)

½ tsp vanilla extract (2 ml)

1 cup flour (128 grams)

½ tsp salt (2 grams)

canola oil

FOR THE STRAWBERRY BUTTER

½ cup butter (113 grams)

3–5 strawberries (diced)

1 tbsp powdered sugar (12 grams)

⅓ tsp vanilla extract (1 ml)

DIRECTIONS

1 Take the butter, eggs and milk out of the refrigerator, and let these ingredients come to room temperature.

2 Melt 1 tablespoon butter in a saucepan or microwave.

3 In a blender, combine the melted butter, eggs, milk, and vanilla extract, and blend.

4 Add the flour and salt and blend for 15 seconds or until well-combined and bubbly. Then let the batter rest for 1 hour at room temperature.

5 In the meantime, make the strawberry butter: Blend the room-temperature butter with the diced strawberries, powdered sugar, and vanilla extract until smooth. Wrap in parchment paper and refrigerate until ready to use.

6 Preheat the oven to 450° F (235° C) and place the oven rack on the second-to-last rung.

7 In a muffin pan, place ¼ teaspoon of canola oil in each of the outer cups (leaving the center 2 cups empty). Once the oven is preheated, bake the muffin pan for 15 minutes.

8 Carefully remove the hot muffin pan from the oven, stir the batter, and fill each cup halfway up with batter. Then place back in the oven.

9 Bake for 10 minutes or until the batter has popped (risen).

10 Without opening the oven, lower the temperature to 350° F (180° C) and bake for an additional 20 minutes until the tops are golden. (Make sure they don't burn.)

11 Remove the popovers from the pan and let cool on a wire rack. Gently poke holes in the bottoms to allow the heat to escape. Enjoy while hot.

NOTE The key to this recipe is to lower the heat mid-bake. The high temperature creates fluffy, cloud-shaped cakes, but it would burn the tops if it continued to bake through the remaining time without the reduced temperature. You can also add herbs or cheese to the batter for a savory version.

GRANDMA TERESA'S OMELET

SERVES: 2

DIRECTIONS

1 Separate the eggs, placing the whites in a large bowl and yolks in a small cup.

2 Add a pinch of baking powder and a pinch of salt to the egg whites, and beat using an electric mixer until foamy but not firm.

3 Add the yolks and beat until well-combined.

4 Chop up any vegetables, meats, or fruits for your filling, and have them ready to quickly add when needed.

5 Heat butter and spread in a large nonstick pan over medium heat.

6 Pour the eggs evenly into the pan. After 1 to 2 minutes, scrape around the edges with a spatula to see if the bottom is browned. (Timing will depend on the size of your pan and the thickness of the egg.)

7 Lower the heat to medium low and add your choice of fillings to one half of the pan, then carefully fold the other half of the omelet over the filling and continue cooking for 1 to 2 minutes. Carefully flip the omelet and cook the other side for another minute.

8 Remove to a plate and season with salt and pepper (if your omelet is savory). Serve immediately.

INGREDIENTS

4 eggs

a pinch of baking powder

a pinch of salt

½ tbsp butter (7 grams)

salt and pepper

SAVORY FILLING OPTIONS:

cheddar cheese, spinach, onions, scallions, peppers, ham, tomatoes, garlic, cooked chicken, mushrooms, smoked salmon, (basically anything that can be eaten raw or without much cooking)

SWEET FILLING OPTIONS:

jam or preserves, fresh fruit, sugar, chocolate

NOTE When Grandma Teresa made this omelet, it drove her crazy whenever it would collapse, just like a soufflé. This happens because the air in the egg whites (which creates the fluffy, light texture) cools and deflates the omelet. Don't worry—collapsing won't affect the omelet's taste, but if you want the omelet to stay pretty, then serve it immediately.

WEST COAST BENEDICT

SERVES: 2

INGREDIENTS

2–4 eggs (based on how many you want)

a handful of spinach

salt and pepper

1 tbsp rice vinegar (15 ml)

1 tbsp butter (14 grams)

⅓ cup heavy cream (80 ml)

⅓ cup shredded cheddar cheese (40 grams)

½ tsp lemon juice (2 ml)

2 English muffins

1 package (2 oz) smoked salmon (60 grams)

DIRECTIONS

1 Crack the eggs into small individual cups or bowls.

2 Fill a deep-sided pan (about 2 inches tall) with water so it comes up 1½ inches and bring the water to a simmer.

3 Place a handful of spinach in a small pan. Season with salt and pepper and cook covered, over medium-low heat, until wilted.

4 Using a thermometer, test the water. Once it has reached 180 °F (82 °C), add the rice vinegar and stir. Gently add each egg into the water (making sure they don't touch), and cook for 4 to 5 minutes.

5 Heat a small saucepan over medium heat and melt butter. Add heavy cream and whisk. Add the shredded cheddar cheese little by little, so the sauce doesn't become too thick. (Be sure to dip your finger in and taste as you go— you might not want to use all the cheese.) Whisk continually until smooth. Add lemon juice and a pinch of salt to taste.

6 Toast your English muffins.

7 Remove the poached eggs from the pan with a slotted spoon and place on a paper towel to absorb the excess water. Cut off any odd strings or rough edges (optional).

8 Assemble the Benedict: Start with the English muffin, then pile on the spinach, a few slices of smoked salmon, and the poached egg. Pour the sauce on top.

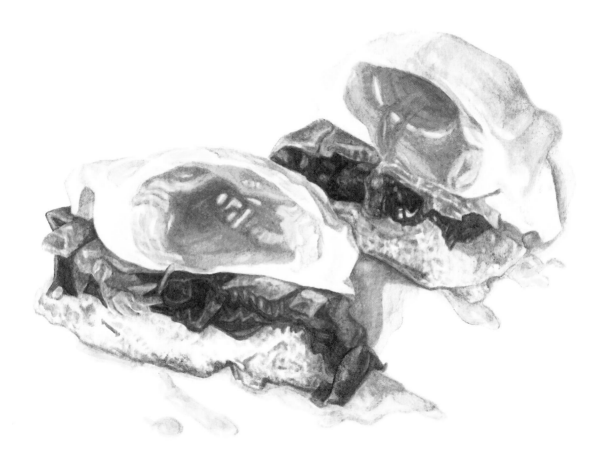

NOTE A traditional Benedict uses a hollandaise sauce, but this recipe calls for a simpler, cheesier version that is a good entry-level sauce to go with an already complicated dish. The other version I like is called a SoCal Benedict and uses avocado instead of salmon.

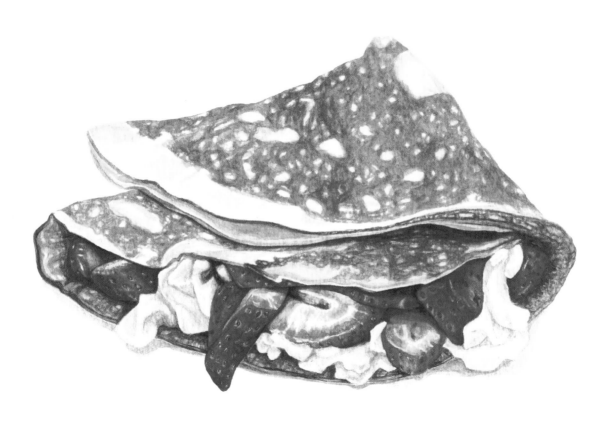

CRÊPES WITH STRAWBERRIES & CREAM

SERVES: 2

DIRECTIONS

1 Combine the water, milk, eggs, baking powder, and flour in a blender and blend until smooth. Make sure there are no lumps.

2 Heat a large pan over medium heat. Add a few drops of canola oil and use a paper towel to spread the oil evenly over the pan. (You will need to re-oil every 5 to 6 crêpes, so keep that paper towel handy.)

3 Pour some batter into the pan so you have a thin, even layer. Tip and rotate the pan to make the crêpe as thin as possible. Flip the crêpe over when the edges begin to brown and lift, then stack the finished crêpes on a plate. Cover with a clean dish-towel to keep them warm. Repeat this process until all the batter is used.

4 Using an electric mixer, whip the heavy cream until firm. Add the lemon juice and vanilla extract and continue mixing. Slowly add the confectioners' sugar until well-combined.

5 Wash and slice the strawberries.

6 Fill each crêpe with the whipped cream and strawberries and fold or roll up.

INGREDIENTS

1½ cups water (350 ml)

1½ cups milk (350 ml)

2 eggs

½ tsp baking powder (2 grams)

5 tbsp flour (40 grams)

a few drops of canola oil

1 cup heavy cream (235 ml)

¼ tsp lemon juice (1 ml)

¼ tsp vanilla extract (1 ml)

2 tbsp confectioners' sugar (15 grams)

2 cups fresh strawberries (450 grams)

NOTE Crêpes without any filling will keep very well in the refrigerator stored in an airtight container or (even better) on a plate covered with cellophane for up to 2 days. They make an excellent cold snack when served with jam. Instead of folding, you can also roll them for more portable snacks.

SALADS

FOR MOST OF MY CHILDHOOD AND YOUNG ADULT LIFE, I WOULD ONLY EAT SALADS FOR SHOW, preferring a large bowl of pasta in secret. My diet was mostly carb-based, which was fine when I had a child's energy level, but then age started catching up with me. I started feeling terrible after eating my normal meals—moody, lethargic, depressed—and was having serious digestive problems.

I was convinced that something was wrong with me and went to a number of doctors. They ran tests, and a few thousand dollars later the prognosis was that I was perfectly healthy, but maybe I had IBS? . . . Wonderful.

I needed to change my diet, stress-levels, and exercise routine. Seriously? Just give me a pill. I was in NYC working and painting; I didn't have time for this. I started taking fiber pills, which actually did help a lot, but I knew I needed to make those lifestyle changes somehow. And then I had that breakdown. Perfect timing.

Before I moved to LA, I really, really tried to make the NY art thing work. I quit my job and moved in with one of my best friends, who is an amazingly talented illustrator and writer, Forsyth Harmon. As I didn't know how to eat properly, I basically adopted her diet, and thank goodness I did, because she's a very health-conscious individual and a fabulous cook.

My diet switched overnight, from high-carb to high-protein. We ate a lot of delicious salads, which was intriguing to me since I had no idea salads could be so satisfying. We'd walk to the local grocer and this is what we'd buy: organic free-range chicken, free-range brown eggs, no-nitrate/preservative/antibiotic bacon, the biggest vat of organic spinach available, red onions, tomatoes, avocados, and sometimes the fresh, deli-made salsa mix.

The rotation: 1—Bacon and eggs over spinach with some extra-virgin olive oil, salt, pepper, herbes de Provence, and balsamic vinegar for a dressing. 2—Chicken over spinach with the same dressing. 3—Chicken over spinach with salsa and guacamole (and maybe some black beans).

Miraculously, my digestive problems went away. Like, I forgot I even had a stomach, that's how much this affected my life. I also lost weight. When you eat a predominantly high-protein, high-fat, low-carb diet, there's not enough carbs to convert to glucose, so

your liver converts fat into ketones and your body burns that for energy instead. This metabolic state is called ketosis and it helped me get my body back to a healthy and clean digestive state.

I'm very grateful for Forsyth's help during that confusing time. The switch from carbs to salads was not as painful as I had imagined. That one change allowed me to make other small, but positive changes, which thankfully led to the decision to let go of my desire to stay in NYC and go home to my husband.

When I moved to LA, my life flipped upside down (or maybe right-side up). It was the opposite of my time in NYC. I became more laid back. Things happened when they happened—no one was pushing or pulling me anymore. I felt emptied of my past, unburdened from my goals, and I just floated. I ate my salads, and with all the fresh, local produce at seemingly half the price, I began to buy different greens to see what else I could make.

These are the salads that I learned, in addition to fancier versions of the originals that got my life back on track. Those lifestyle changes had seemed so impossible before. And even though it was difficult, I truly do believe that I would be in the same gut-wrenching state or worse if I hadn't changed my mind about salads. Just try them and see.

THOSE GREEN THINGS

If you want to start eating healthier, salads are a surefire way to do so. With a little prep work, you've got a week's worth of lunch for pennies and a million different ways to make each dish uniquely yours. A good way of streamlining salad-making is to wash, dry, and divide your greens into small containers right after buying—particularly in regards to pre-washed, mixed packages, which can spoil quickly if there are a few soggy leaves in with the good ones. Be sure to pick through them and, if washing, I highly recommend purchasing a salad spinner. Then all that is left to do is add a dressing or a few simple ingredients, and it's ready to eat.

Common Salad Greens

You probably know these already, but to be thorough I had to include them! I, for one, learned something while writing this, and who knows: In a century or so, these plants might be untrendy or totally different in taste and shape.

Spinach: This is definitely my green of choice. Familiar, no chopping required, and versatile as a cooked side or in a soup. You can buy the slightly bitter flat or smooth-leaf spinach in prewashed containers or the savory variety as bunches in the produce section. There is also a hybrid called semi-savory. Hearty and rich in iron, potassium, calcium, and even some protein, it's a very healthy option.

Arugula: a.k.a. salad rocket or rocket. It has a sharply bitter and peppery taste and is often mixed with other greens to balance out the flavor. Goes well with roasted vegetables or fruits.

Kale: This leaf can be green or purple, and it is further subdivided by its leaf-type. The most common types are curly (bright green or purple with ruffled edges), dinosaur (narrow, deep evergreen-colored, with long, wrinkled leaves), and red Russian (green-leaved with purple stems). It has an earthy taste because it's part of the Brassica family (cabbage, collards, Brussels sprouts).

Lettuce Varieties: The word "lettuce" can mean sooo many things—iceberg, butterhead, Bibb, green leaf, red leaf, oak leaf, romaine, etc. These are mostly the brighter, lighter, green-colored leaves. Crunchy, watery . . . need I say more?

Endive: Part of the *Chicorium* genus (along with chicory), the endive is a small white-and-yellow or light-green-tipped oval bulb. It's tender with smooth leaves, which work well for dipping or filling with additional ingredients.

Frisée: a.k.a. curly endive. This leaf has become more popular recently, and it can fancy up your salad repertoire. It has wild-looking, narrow, lacy, yellow-green leaves that add great texture with a touch of bitter nuttiness.

Escarole: a.k.a. broad-leaved endive. Escarole has wide, frilly leaves. Often mistaken for green leaf lettuce, it can be eaten raw or cooked. It has a mildly bitter and thicker leaf than lettuce, and it is commonly used in soups or cooked with beans.

Radicchio: Looks like a reddish-purple lettuce or endive and really brightens up a salad. Its leaves are crisp, bitter, and peppery when eaten raw but become sweet when cooked. It goes well mixed with other greens in a citrus dressing.

Watercress: This is a small aquatic plant that looks like tiny spinach or large sprouts. It

has a tangy, peppery taste, can be eaten raw or cooked, and is super nutritious. Since it grows in water, it should be thoroughly cleaned before consuming.

Mixed Greens: Found in farmers' markets or in prewashed packages, these are typically a combination of baby lettuce varieties, often mixed with arugula. They are economical and convenient, but can spoil quickly if you don't prep them. To save you from wilted, slimy greens, I recommend sorting through the package for bad leaves as soon as possible and wrapping the salad in paper towels before placing in a container. Press out as much air as possible in the container before refrigerating.

Salad Dressings

Homemade salad dressings are easy, more flavorful, and way cheaper than the store-bought dressings. You can use a simple mason jar to mix and store your dressings, and once you get a sense of how a few staple ingredients are combined, you can make unique concoctions to your own taste preference. The base of my dressings consists of olive oil and vinegar or citrus juice. Then I add spices or herbs for more flavor, and/or mustard, mayonnaise, buttermilk, or sour cream for a creamier/tangier taste.

Honey Mustard:

Combine ¼ cup extra-virgin olive oil, 1 tablespoon mustard, ½ tablespoon lemon juice, ½ teaspoon dried and crushed oregano, 1 tablespoon honey, and 1 clove squeezed garlic. Stir or shake until well-mixed.

Italian Salad Dressing:

Combine ¼ cup extra-virgin olive oil, 1 tablespoon white wine vinegar, 1 clove squeezed garlic, 1 tablespoon minced shallot, ½ teaspoon dried and crushed oregano, ¼ teaspoon red pepper flakes, ½ teaspoon dried basil, and 1 teaspoon brown sugar. Stir or shake until well-mixed.

Balsamic Vinaigrette:

Combine ¼ cup extra-virgin olive oil, 1 tablespoon balsamic vinegar, ½ tablespoon honey, 1 clove minced garlic, ⅛ teaspoon dried and crushed oregano, and a pinch of salt and pepper. Stir or shake until well-mixed.

Ranch:

Combine ½ cup buttermilk, 2 tablespoons mayonnaise, 2 tablespoons sour cream, 1 teaspoon dried dill, 1 clove squeezed garlic, a light squeeze of lemon juice, and a pinch of pepper. Stir or shake until well-mixed.

Blue Cheese:

Combine ¼ cup blue cheese crumbles, ¼ cup mayonnaise, 1 tablespoon extra-virgin olive oil, a light squeeze of lemon juice, and a pinch of pepper. Stir or shake until well-mixed.

Miso & Carrot:

This is a really amazing dressing, although you need a blender. Similar to the dressings you get when you go to a Japanese restaurant, its thick and spicy taste is really unique. Combine 1 carrot (roughly chopped), ¼ onion (roughly chopped), ¼ cup rice vinegar, ¼ cup olive oil, 2 tablespoons white miso paste, 1 tablespoon sugar, and 1 teaspoon sesame oil. Season with salt and pepper to taste.

STRAWBERRY & BALSAMIC SALAD

SERVES: 2

DIRECTIONS

1 Wash the spinach and strawberries. Let them air dry or gently pat them dry.

2 Chop the strawberries into halves or quarters.

3 In a cup, mix the balsamic vinegar, honey, and olive oil, and add a pinch of salt and pepper.

4 Combine the spinach, strawberries, walnuts, and cheese in a large bowl.

5 Pour the balsamic vinaigrette over the salad just before serving to prevent sogginess.

6 Toss and enjoy!

INGREDIENTS

4 to 5 handfuls of fresh spinach

1 cup strawberries (225 grams)

1 tbsp balsamic vinegar (15 ml)

1 tbsp honey (15 ml)

2–3 tbsp extra-virgin olive oil (15-45 ml)

salt and pepper

½ cup walnuts (60 grams)

½ cup feta or gorgonzola cheese (optional)

NOTE Strawberry season falls between June and mid-August, and the moment I start seeing these little ruby darlings in farmers' markets, I make this recipe. The balsamic vinegar counterbalances the sweetness of the strawberries, but the key to making this salad even better is to buy high-quality balsamic vinegar.

GARLIC BREAD SALAD

SERVES: 2

DIRECTIONS

1 Rinse and roughly chop the romaine lettuce, dice the scallions, slice the tomato and red onion, and toss in a large salad bowl.

2 Peel the eggs, cut them into halves or quarters, and add to the salad bowl.

3 Chop the French bread into cubes.

4 Heat 1 tablespoon olive oil in a pan and sauté the bread over medium heat.

5 Add 1 clove minced garlic to the bread and stir until the bread is browned, then add to the salad bowl.

6 In a small bowl, combine the olive oil, balsamic vinegar, the remaining minced garlic, crushed oregano, and honey. Add salt and pepper, mix well, and drizzle over the salad. Toss and serve immediately.

INGREDIENTS

½ head romaine lettuce

2 scallions

1 medium heirloom tomato

½ red onion

1 to 2 hardboiled eggs

2 slices of fresh French bread

2 garlic cloves, minced

extra-virgin olive oil

1 tsp balsamic vinegar (5 ml)

½ tsp dried oregano (2 grams)

1 tsp honey (5 ml)

salt and pepper

NOTE Don't ever throw away old, stale bread, just turn it into croutons or—better yet—garlic croutons. You can also use fresh bread for a spongier, soft texture. These croutons can be stored in an airtight container or Ziploc bag in the refrigerator for up to one week.

BALSAMIC CHICKEN SALAD

SERVES: 2

DIRECTIONS

1 Chop the tomato and place in a small bowl. Add 1 to 2 teaspoons balsamic vinegar and a few shakes of salt and pepper. Stir and let it rest.

2 Wash the spinach and let it air dry or pat it dry.

3 Slice the red onion and cut the chicken into cubes or strips. Season the chicken with salt and pepper.

4 Heat ½ teaspoon olive oil in a large pan over high heat. Once the pan is very hot, add the chicken and brown both sides (flip only once).

5 Reduce the heat to medium low and add the onions. Then add 2 to 3 teaspoons balsamic vinegar and the dried oregano and stir. Cook for 5 minutes or until the onions are translucent and the chicken is cooked through.

6 Thinly slice some Parmesan or Manchego cheese and slice the avocado.

7 On a plate, layer a handful of spinach, the avocado, cheese, chicken and onions (make sure to add any yummy liquids from the pan), and pour the tomato mixture on top. Add a little extra-virgin olive oil if you need more dressing and season with salt and pepper to taste.

INGREDIENTS

1 small tomato

3–5 tsp balsamic vinegar (10–25 ml)

salt and pepper

a handful of spinach

½ red onion

1–2 chicken breasts

extra-virgin olive oil

½ tsp dried oregano (2 grams)

a small chunk of Parmesan or Manchego cheese

½ avocado

NOTE This is the recipe that I used to reset my life and digestive tract. It's the perfect balanced meal, with a good proportion of protein, carbohydrates, and healthy fats. You can also adjust it to suit your daily needs. So, if you're going to work out, add more chicken, or if you'll be sitting in a chair all day, add more spinach.

KALE SALAD

DIRECTIONS

1 Wash the kale and let it air dry or pat it dry with paper towels. Remove the stems and chop the leaves into bite-size pieces. Place in a bowl and squeeze in ½ a lemon, add a splash of olive oil, then massage the leaves with the liquids and let the mixture rest for 5 minutes or more.

2 Cut the apple and avocado into similar-size pieces.

3 Add the apple, avocado, dried cranberries, and pine nuts to the kale.

4 In a small bowl, combine the olive oil, Dijon mustard, honey, minced garlic, and oregano. Whisk until smooth, then pour over the salad.

5 Season with salt and pepper.

INGREDIENTS

5 large kale leaves

½ lemon

extra-virgin olive oil

½ crisp apple

½ avocado

a handful of dried cranberries

a handful of pine nuts

3 tbsp olive oil (44 ml)

1 tsp Dijon mustard (5 ml)

1 tsp honey (5 ml)

1 garlic clove, minced

½ tsp dried oregano (2 grams)

salt and pepper

NOTE Kale is a bit finicky, but once you get over its rough edges, its rich, earthy taste is hard to beat. To improve kale's disposition, you need to remove the stem, and chop or tear the leaves into smaller pieces. Then massage those stiff dark greens until velvety. You can also squeeze in ½ a lemon, then let the leaves rest for 10 to 30 minutes to soften further.

BEET & CHEESE SALAD

SERVES: 2

DIRECTIONS

1 Preheat the oven to 400 °F (200 °C).

2 Clean and dry the beets and remove the stems. Drizzle olive oil on top with salt and pepper, then wrap the beets in aluminum foil and place on a baking pan.

3 Bake for 1 hour or until tender and let cool for 5 minutes before unwrapping. Continue to let the beets cool down until they are at room temperature or cold (depending on your preference).

4 Peel and chop the beets then place in a bowl with a few splashes of balsamic vinegar.

5 Wash and dry the arugula and place a handful on a plate, then sprinkle the walnuts on top.

6 Add the cheese and drizzle with a splash of olive oil and balsamic vinegar. Add the chopped beets and season with salt and pepper.

INGREDIENTS

1–2 beets

extra-virgin olive oil

salt and pepper

2 tbsp balsamic vinegar (30 ml)

a handful of fresh arugula

a handful of walnuts

1 medium ball of fresh burrata cheese or fresh mozzarella cheese

NOTE Beets are so much more than just a side. If you're thinking of the canned version, you are going to be totally blown away by how much better they are when freshly roasted. Just wrap them in some aluminum foil and bake for an hour and they're ready to use in salads, on pizzas, or as a great natural food coloring to homemade pastas.

EDAMAME SALAD

SERVES: 6

DIRECTIONS

1 In a small pot, combine quinoa with water and bring to a boil, then reduce to a simmer and cook covered for 10 minutes. Lightly fluff using a fork, then let it rest.

2 Bring another pot of water to a boil. Add a pinch of salt and the fresh or frozen edamame beans (in pods). Boil for 5 to 6 minutes, then let them cool until you can peel them with your hands. Remove the beans from the pods and discard the pods. (Alternatively, some stores sell cooked and shelled edamame in the vegetable section.)

3 Dice the scallions, red onion, red pepper, and carrot. Cut the corn off the cob if using fresh corn, or drain the canned corn. Drain the black beans.

4 Combine the edamame, corn, scallions, red onion, red pepper, carrot, black beans, and cooked quinoa.

5 In a small bowl, combine the soy sauce, rice vinegar, sesame oil, honey, and minced garlic. Stir well.

6 Drizzle the dressing over the salad. Mix well and refrigerate. Serve cold.

INGREDIENTS

½ cup quinoa (100 grams)

1 cup water

salt

1 cup edamame, fresh or frozen (155 grams) or ½ cup precooked edamame

2 scallions

¼ red onion

1 small red pepper

1 carrot

½ cup corn, fresh or canned (100 grams)

¼ cup black beans, cooked or canned (60 grams)

2 tbsp soy sauce (30 ml)

1 tbsp rice vinegar (15 ml)

1 tbsp sesame oil (15 ml)

2 tsp honey (10 ml)

1 garlic clove, minced

NOTE Edamame is actually an immature soybean—that's why they are green instead of white. The creamy, nutty taste adds a refreshing, earthy flavor, and like most beans, they're high in fiber and protein. It doesn't take a lot of this salad to feel full, and it can be saved in the refrigerator for up to 5 days.

POLISH VEGETABLE SALAD

SERVES: 8

DIRECTIONS

1 Wash and peel the carrots, parsnips, and potatoes, and cut each in half. Place in a large pot of water and bring to a boil. Add the bay leaf and peppercorns and cook for 20 minutes, until tender but not mushy. (Do not overcook.)

2 Strain the vegetables and let them cool completely.

3 Hard boil the eggs in boiling water for 10 to 15 minutes and let them cool.

4 Dice the cooked vegetables, apple, and pickle into small, similar-size cubes. Place in a large bowl and add the peas.

5 Peel the eggs and separate the whites from the yolks. Dice the egg whites and add to the bowl.

6 Add the olive oil, honey, mayonnaise, mustard, egg yolks, and a pinch of pepper, and whisk until smooth.

7 Add the dressing to the vegetable mixture and combine by stirring gently (so you don't squish or mash the vegetables).

8 Place in a bowl covered with cellophane and refrigerate. Serve chilled.

INGREDIENTS

2 carrots

2 parsnips

2 medium potatoes

1 bay leaf

3 peppercorns

2 eggs

½ apple (honeycrisp or another sweet variety)

1 dill pickle

½ cup sweet peas (80 grams)

1 tbsp extra-virgin olive oil (15 ml)

1 tsp honey (5 ml)

2 tbsp mayonnaise (30 ml)

2 tbsp mustard (30 ml)

a pinch of pepper

NOTE In my opinion, this vegetable salad kicks the traditional egg salad in the butt! It's way more complex and delightful, with the crunch of the apple and the tang of the pickle. You may be able to find this premade at Polish delis during Christmas or Easter, if you're lucky. It's best eaten over some hard brown flax crackers.

FORSYTH'S SALAD

SERVES: 4

INGREDIENTS

1 cup rice (230 grams)

1½ cups water

a handful of spinach

1 large chicken breast

salt and pepper

½ red onion

1 bell pepper

¼ tsp ground cumin (1 gram)

¼ tsp chili powder (1 gram)

¼ tsp dried oregano (1 gram)

extra-virgin olive oil

½ avocado

1 radish (optional)

½ cup canned black beans (120 grams)

DIRECTIONS

1 Bring rice and water to a boil. Reduce to a simmer, cover, and cook for 10 to 15 minutes, or until the rice has cooked through (you may need to add more water and continue to cook, so taste before you remove from the heat).

2 Wash and dry the spinach.

3 Season the chicken breast with salt and pepper and cut into ¼-inch strips.

4 Chop the onion into rings and the pepper into ¼-inch strips.

5 In a small bowl or cup, stir together the ground cumin, chili powder, and dried oregano.

6 Heat a pan with a few drops of olive oil over high heat and wait until the pan is very hot. Add the chicken and brown all the sides.

7 Reduce the heat to medium and add the onions, peppers, and spice mixture. Stir. Cook until the onions are translucent and the chicken is cooked.

8 Slice the avocado and radish and rinse the black beans thoroughly.

9 Arrange a handful of spinach on a plate and drizzle with a little extra-virgin olive oil. Add a scoop of rice, the chicken and vegetables (including any pan juices), the avocado, radish, and beans, and season with salt and pepper.

NOTE Similar to the Balsamic Chicken Salad recipe (pg 59), this is an even healthier option since it uses beans for added protein. What makes this work is the cumin. If you're trying out new spices, definitely make sure cumin is part of your collection. Its distinct flavor and aroma will add a deep, pungent heat to any dish.

DAIKON SALAD

SERVES: 4

DIRECTIONS

1 Slice the daikon and cucumber into thin disks and chop the carrot into small sticks.

2 In a medium-size bowl, mix the sugar and salt into the rice vinegar until dissolved.

3 Add the daikon, cucumber, and carrots to the bowl and mix using your hands, so everything is evenly coated. Let it soak for 5 minutes.

4 To plate, stack the daikon, then the cucumber, then the carrot, and drizzle a little bit of the leftover rice vinegar mixture over the vegetables.

5 Season with toasted sesame seeds. (If you can't find toasted sesame seeds, you can take regular sesame seeds and place them on a dry pan over medium heat, and cook until lightly browned.)

INGREDIENTS

¼ daikon radish

½ cucumber

¼ carrot

1 tbsp sugar (15 grams)

a pinch of salt

2 tbsp rice vinegar (30 ml)

toasted sesame seeds

NOTE Refreshing, light, and crunchy, this salad is insanely simple—almost too simple. Great for hot summer days, I like to eat this with a bowl of miso soup and vegetable tempura. If you can't find daikon radish, you can use more cucumber or replace it with any other type of radish.

COLESLAW

SERVES: 8

DIRECTIONS

1 Thinly slice and shred the cabbages and carrot into similar-size pieces.

2 Place vegetables in a bowl and add salt and 1 tbsp sugar, and let it sit for 5 minutes to remove the water.

3 Rinse the salt and sugar off the cabbage-and-carrot mixture and gently squeeze out the water. Pat the cabbage and carrots dry with paper towels.

4 In a large bowl, combine the mayonnaise, remaining sugar, milk, rice vinegar, and the juice of ½ a lemon. Stir, then add the cabbage.

5 Season with a pinch of pepper and toss using your hands so everything is evenly coated.

6 Refrigerate for at least 1 hour and up to 2 days. Serve cold.

INGREDIENTS

¼ red cabbage

½ savoy or green cabbage

1 carrot

1 tbsp salt (12 grams)

2 tbsp sugar (30 grams)

½ cup mayonnaise (120 ml)

¼ cup milk (60 ml)

1 tbsp rice vinegar (15 ml)

½ lemon

pepper

NOTE This dish tastes better the day after, so make it ahead of time if you can. The more time the cabbage has to absorb the dressing, the better it's going to taste. Something that may surprise you when making this recipe is the amount of liquid the cabbage will expel. Just drain that off before you serve and you're good to go.

SANDWICHES

EGGS AND SALADS ARE GREAT, BUT SOMETIMES YOU JUST NEED A SANDWICH. AFTER getting my gut in order, I began to add a few things back into my diet, and bread was one of them. Yes, I know that bread is the enemy of diets and people with yeast sensitivities, but for me, that first bite into a French baguette was downright orgasmic.

I had forgotten how amazing bread was, and because Piotr was a bread-lover, learning how to make really intense sandwiches was inevitable. Sandwiches also bring up some of my best travel memories. Their versatility and portability make them an ideal food for managing low blood sugar or just keeping you well-fed when you're broke.

On my first trip to Europe, one of the places I wanted to see most was the ruins of Pompeii. It's about a 30-minute train ride from Naples, where my friend Jee and I were staying. We had booked a hostel and arrived really late in the pouring rain. I was feeling extremely tired, cold, and scared, and the moment we dried off, I passed out.

The next morning, I was apprehensive about where we were. It was dark when we'd arrived the previous night, and we took a taxi to the hostel, which was actually someone's house! (This was pre-Airbnb.) The complimentary breakfast was early, so we got up and walked outside into a gorgeous mini orchard of lemon trees. The sun was up and we headed to the main house, where we had fresh soft-boiled eggs with red-orange yolks, salami sandwiches, and coffee. The couple who owned the place were very kind and let us pack some sandwiches with us after we left.

I ate more sandwiches than I did pasta in Italy, and it was the same in Germany and Poland. After a few days of backpacking, I learned to carry around bread, cheese, and hard meat, in case I didn't find or couldn't afford the local restaurants. Going out to eat in Europe was totally different abroad than it was in the US—although food at the grocery stores was surprisingly cheap, restaurants were crazy expensive. Plus there was the *riposo*, a time when everything closed for two hours in the afternoon, including cafés at lunchtime!

When I started buying freshly baked bread again, and heard that crisp crust crackle, all those memories came back to me. A fresh slice of bread and cheese topped with cold cuts, tomatoes, or arugula became a part of our breakfast/lunch rotation. I started

recalling other sandwich memories—like that super-greasy, melt-in-your-mouth chicken gyro that I ate on the island of Rhodes. How it was so hot outside I literally burned my hands on the aluminum foil wrapping. Or the classic lox bagel sold at practically every deli, on every corner in Manhattan.

Or, more recently, that road trip to see the beautiful, naturally carved walls of Antelope Canyon in Arizona. It's located on Navajo land, and the closest city is Page, a small, touristy rest stop in the middle of the desert. I was looking on Yelp for a place to eat and, hands down, the restaurant that had the most reviews and highest ratings was the local BBQ joint. We didn't really have to map it, we just followed our noses to a gas station-turned-café (extra points for casual dining!). And wow—that BBQ was the best I've ever eaten. My favorite dish was the pulled pork, which I vowed to learn how to cook when I got home.

So we began experimenting with cooked meats. It was BBQ season, after all. These sandwich recipes can be a bit challenging, since many of the meats need to be slow-cooked and then re-cooked, but it really does layer and enhance the taste until it becomes something, well, memorable.

I ♥ BREAD

Sandwiches are the ideal food for lunch, parties, or BBQs. These recipes are not your quick, cold-cut comestible, but a warm, satisfying labor of love. Who knew sandwiches could be so amazing? And if you're a bread-lover, this section was written particularly for you. Learning to make a quality sandwich is one of those adult transitions that we all eventually (and thankfully) discover.

Sandwich Basics

The Outer Layer: Choosing the proper outer layer is obviously step one. There are many options for bread or bread-like materials that can either enhance or detract from the other ingredients, so it's worth thinking about. Freshly baked bread is best, and wheat/

multigrains are even better. And nowadays, there are gluten- and yeast-free bread options, typically found in the freezer section of the grocery store. If carbs are an issue, consider an open-faced sandwich or substituting lettuce or vegetables for the bread.

Meats/Veggies: Cold cuts are also an important part of sandwich-making, and come in a range of meats (ham, turkey, bologna, roast beef, etc.) and types (smoked, cured, oven-roasted, salted, etc.). But it should be noted that however wonderful cold cuts are, most contain nitrates that preserve the meat, and have been linked to health concerns. There are three types of cold-cut meats—whole cuts, which have been cooked and flavored as one piece; sectioned/formed meats, which are separate meat chunks bonded together; and processed meats, which have been chopped, seasoned, and formed into consistent shapes. Whole cuts are the best of these options and it is always ideal to purchase them from your local deli or butcher, who can tell you where the meat is coming from, how it's been processed, and what you're getting.

However, there isn't any cooking required for cold-cut sandwiches, so the recipes in this section use fresh meats and vegetables. *Fresh* is the key word, because why go through the trouble of all this cooking without the best ingredients. Right?

Toppings: This is the area where you can have some fun and change things up. My recipes are just guidelines, and once you make them, you'll know how they taste and where you'll want to make your own additions and subtractions. Less meat, more veggies . . . whatever you like best.

Condiments: I stick with the basics in the condiments world. You will need mayonnaise, soy sauce, and sriracha, but anything else is up to you. Go crazy.

Balance: Simplicity is key. Using too many contrasting flavors can be confusing for your palette and, overall, unsatisfying. I've had a few contemporary sandwiches that were novel, but at the end of the day, I want something that I can recognize and which has unity. A good standard is to keep the ingredients to six or fewer (counting a marinade as part of the main ingredient).

Appreciation: Since these sandwiches are cooked, it's best to eat them sitting down and right away. While there are a few recipes that can be stored and eaten while walking or driving, it's always good to take a moment and enjoy the food you've made. Leftovers, however, are a different story, and most of these recipes can be reheated to near-perfection if you keep the meats, veggies, and bread stored separately and assemble right before eating.

HOW TO MAKE FRENCH BREAD FROM SCRATCH

MAKING FRENCH BREAD IS REALLY NOT AS FRIGHTENING AS YOU MIGHT THINK. IT'S ACTUALLY super easy, but does require having time to knead the dough. The key to a really delicious French bread is the quality of the yeast (so buy the best you can, preferably the kind that needs to be refrigerated, such as Fleischmann's active dry yeast).

To begin, you need to make a mixture called a sponge or yeast starter. This is a simple combination of yeast, flour, and warm water, and will determine the taste and texture as it ferments.

The next step is to combine the sponge with the dough and knead well. To knead, form into a ball over a floured surface, get your hands floured too, and push down and out. Fold over and down and out again. You want to try and get into a rhythm and make sure you're not just kneading one section, but gently rotating and moving the dough along to get it all equally mixed.

This process is a good workout. At the end of kneading, you should have smooth, firm dough without any lumps. Then it's just setting a timer and letting the dough rise, after which you bake it and voilà, you have made bread!

INGREDIENTS

2 tsp active dry yeast

6 cups bread flour

1¾ cups warm water

2 tsp salt

spray bottle of water

towels

1 Make the sponge: In a large mixing bowl, combine 1 tsp active dry yeast, 2 cups bread flour, and 1½ cups warm water. Make sure the water is between 80 to 90 °F/26 to 32 °C.

2 Let the sponge rest for 1 to 2 hours until large and bubbly.

3 In a small bowl, combine 1 tsp yeast and ¼ cup warm water (80 to 90 °F/26 to 32 °C) and mix until it has dissolved.

4 Add the yeast mixture, 3 cups bread flour and salt to the sponge and mix well in the bowl. (If it looks too dry, add a very small amount of water.)

5 Prepare a floured surface and knead the dough for 10 minutes. Try to use as little flour as possible.

6 Form the dough into a ball and place back in the mixing bowl. Cover with a towel and leave on the counter at room temperature for 2 hours, or until it has doubled in size.

7 On a floured surface, divide the dough into 4 pieces and form each into a ball. Cover with a towel and let the dough balls rest for 10 minutes.

8 Flatten each ball of dough and roll into long loaf shapes. Place on a towel and cover with a light layer of flour, then create folds to separate each loaf so they don't stick to each other. Cover with a different towel and let them rest for 1 hour at room temperature.

9 Preheat to 425 °F.

10 Brush the tops of the bread with a little water if they look dry. Score shallow, diagonal cuts on the tops of the loaves to allow them to expand during baking.

11 Place two of the loaves on a lightly oiled baking pan and put the pan in the oven. Bake for 8 minutes, then, using a spray bottle of water, spritz the loaves and bake for another 7 minutes.

12 Turn the baking pan to get an even bake, spritz the loaves again, and bake for another 5 minutes. Then remove and let them cool. Repeat with the other two loaves.

SMOKED SALMON BAGEL

SERVES: 2

DIRECTIONS

1 Slice and toast the bagels. (If you don't have a toaster, set the oven to broil and place the bagel halves in the broiler section. Bake for 1 to 2 minutes. Watch them so they don't burn.)

2 Slice the red onion and tomato.

3 Spread cream cheese on the bottom half of each bagel, then layer: capers, onion, tomato, and smoked salmon.

4 Squeeze some lemon juice on top and cover with the bagel tops.

INGREDIENTS

2 everything bagels (or preferred bagel type)

⅛ red onion

¼ tomato

cream cheese

1 tbsp capers (8 grams)

4 oz smoked salmon (113 grams)

lemon wedge

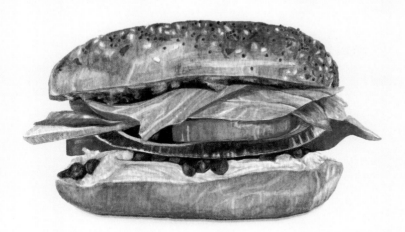

NOTE This sandwich can be found at most delis, but unlike the store-bought kind, when you make it at home you can vary the amount of cream cheese and salmon. It will also cost you a quarter of the price if you make it at home, plus you can add the capers and lemon juice, which makes it so much better. Enjoy with a fresh cup of espresso.

BRUSCHETTA

SERVES: 4

DIRECTIONS

1 Chop the heirloom tomatoes into similar-size cubes and place in a bowl.

2 Add the minced garlic, 1 tbsp extra-virgin olive oil, honey, oregano, a pinch of salt and pepper, and stir well.

3 Cut the bread into ¼-inch slices.

4 Heat a large pan over medium-high heat until hot.

5 Pour 2 tbsp extra-virgin olive oil into a small cup and, using a pastry brush, coat each side of the bread slices, then add to the pan and brown each side. (This makes the bread golden and rich in taste.)

6 Spoon the tomato mixture on the toasted bread, top with a fresh basil leaf, and enjoy immediately, while the bread is still warm.

INGREDIENTS

2 heirloom tomatoes

1–2 cloves minced garlic

3 tbsp extra-virgin olive oil

1 tsp honey (5 grams)

¼ tsp dried oregano (1 gram)

salt and pepper

fresh French baguette

a few leaves of fresh basil

NOTE Heirloom tomatoes are more fragile than most tomatoes and have a short shelf life, so only buy when you are ready to use them. That's why they are so crazy expensive. But they pack more flavor for your buck and come in such beautiful colors and varieties. Be sure to store them on the counter only—do not refrigerate!

LEFTOVER TURKEY SLIDER

SERVES: 1

INGREDIENTS

leftover turkey

leftover stuffing

King's Hawaiian sweet roll

gravy

cranberry sauce

DIRECTIONS

1 In a large skillet, reheat your turkey and stuffing over medium-low heat, and lightly toast the inner sides of the King's Hawaiian sweet roll.

2 Microwave or reheat your leftover gravy for 2 to 3 minutes (depending on quantity).

3 Layer: bottom bun, turkey, cranberry sauce, stuffing. Pour on however much gravy you want, then add the top bun.

NOTE This makes a great midday snack for the people on your couch watching football or reruns of old favorites, instead of the chips and snacks in the pantry. Just remember to make a lot of them, or you'll be returning to the kitchen.

EGG & CHEESE SANDWICH

SERVES: 2

DIRECTIONS

1 Dice the onion and slice the bread.

2 Melt ½ tablespoon butter in a large pan over medium heat. Sauté the onion in the maple syrup until it turns thick, like jam, and season with salt and pepper. Remove from heat and place in a small bowl.

3 Coat both sides of the bread slices with butter and, using the same pan over medium to medium-high heat, fry the bread.

4 Spread the onion-maple mixture on one piece of bread and add a slice or two of Gruyère cheese. Immediately close the sandwich with the other piece of bread so that the cheese will melt from the heat of the bread.

5 Fry an egg and serve on top.

INGREDIENTS

½ white onion

2 slices of fresh sourdough bread

1 tbsp butter (14 grams)

¼ cup maple syrup (60 ml)

salt and pepper

Gruyère cheese

2 eggs

NOTE This sandwich is basically a fancy grilled cheese. Once you try this maple-onion combination, you may need to add it to other carbs, like in a burger, baguette, or on a pizza. Its rich and hearty taste will leave you deeply satisfied. You may need a cup of tea afterward.

THE SUMMER-TIME BURGER

SERVES: 4

INGREDIENTS

1 red onion

3 garlic cloves, minced

2 tbsp butter (28 grams)

1 yellow pepper

4 tsp olive oil (20 ml)

2 tbsp water

1 lb ground beef or buffalo
 meat (450 grams)

½ tsp chili powder (2 grams)

1 tsp dried thyme (4 grams)

1 tsp dried oregano (4 grams)

1 egg

salt and pepper

¼ tomato

a few leaves of lettuce

4 slices cheese (pepperjack,
 cheddar, Swiss, etc.)

4 burger buns

condiments

DIRECTIONS

1 Slice ¼ of the red onion into rings and set aside to serve with the burgers. Dice the rest of the onion.

2 Heat a large pan with butter over medium-high heat and sauté the onion and garlic until golden. Let them cool.

3 Core and quarter the yellow pepper. Sauté over high heat in 1 teaspoon olive oil. Once the skins turn brown and bubble off, flip and add water, cover, and cook for 5 minutes. Then remove from heat and let cool on a plate.

4 In a large bowl, combine the ground beef or buffalo meat and add the chili powder, thyme, oregano, egg, the sautéed onions and garlic, and a pinch of salt and pepper. Using your hands, thoroughly mix all the ingredients.

5 Divide the meat mixture into quarter-pound chunks (or whatever size you would like), roll each into a ball, then squish into patties.

6 Grill the burgers, or heat a large pan with 1 teaspoon olive oil over medium-high heat and cook each side until browned. The internal temperature for a burger (depending on the thickness) should be from 140 °F (60 °C) for medium rare to 160 °F (71 °C) for well-done.

7 When the peppers are cool, peel the skins off and place the peppers on a plate.

8 Slice the tomato, rinse a few leaves of lettuce, and add the sliced red onion rings to the plate.

9 Assemble the burger with the peppers, tomatoes, lettuce, cheese, and any condiments you'd like.

NOTE The big difference between the store-bought burgers and this recipe is the addition of onions and egg inside the meat patties. The egg not only improves the taste but also keeps the meat moist and binds the ingredients together.

TOFU BÁNH MÌ

SERVES: 2

INGREDIENTS

1 package (7 oz) extra-firm tofu
 (200 grams)

¼ daikon radish

½ carrot

2 tbsp salt (24 grams)

1 lemongrass stalk

1 garlic clove, minced

⅓ cup soy sauce (80 ml)

2 tbsp sugar (30 grams)

1 cup white vinegar (240 ml)

¼ white onion

fresh cilantro

½ jalapeño pepper

salt and pepper

2 tsp mayonnaise (10 ml)

1 large French baguette

sriracha sauce (optional)

DIRECTIONS

1 Remove the tofu from the package, place in between 2 paper towels, and put something heavy on top to press out the excess water. (To get tofu to fry, you need to remove as much of the water as possible. I also recommend using extra-firm tofu.)

2 Julienne the daikon radish and carrot (this means cutting it into thin, long strips). Place in a bowl and add 1 tablespoon salt, toss, and let it rest for 15 minutes to extract the water and make it pliable.

3 Remove the tough outer layers of the lemongrass until you reach the softer center. Chop this finely and put it aside in a separate bowl. Add the garlic and the soy sauce and stir to create the tofu marinade.

4 Slice the tofu into thin strips, then add to the marinade. Be sure to coat each side of the tofu in the sauce and let it rest for at least 30 minutes.

5 Once the daikon radish and carrot are bendable, rinse the salt off. Combine the remaining salt, sugar, and the white vinegar and stir. Soak the daikon and radish in this mixture for 30 minutes to pickle.

6 Chop the onion into rings, wash and dry the fresh cilantro, and slice the jalapeño pepper (you may want to use gloves so it doesn't irritate your skin). Keep these ingredients handy to assemble the sandwich.

7 Heat a few drops of oil on a large pan over high heat

and, once hot, carefully add the marinated tofu. Season with salt and pepper and cook each side for about 3 to 5 minutes, or until the edges are browned.

8 Slice the baguette lengthwise without cutting all the way through. Add a layer of mayonnaise on the top and bottom halves.

9 Strain the pickled daikon and radish and add to the sandwich. Layer a few slices of onions, add the tofu and drippings from the pan, then add the jalapeño peppers and cilantro. Add a few squirts of sriracha sauce (optional).

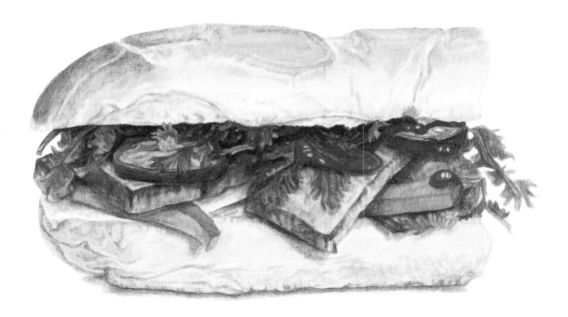

PULLED PORK SANDWICH

SERVES: 6–8

INGREDIENTS

1 white onion

3 large carrots

1 apple

2 tsp paprika (8 grams)

2 tsp chili powder (8 grams)

2 tsp sea salt (8 grams)

1 tsp dried oregano (4 grams)

1 tsp dried thyme (4 grams)

1 tsp garlic powder (4 grams)

1 tsp ground black pepper
(4 grams)

4–5 lbs pork shoulder/pork butt
(113 to 140 grams)

1 tsp extra-virgin olive oil

1 bottle Corona beer

1 scallion, chopped

fresh baguette or buns

fresh coleslaw (pg 73)

2 tbsp brown sugar (35 grams)

2 tbsp rice vinegar (30 ml)

1 tbsp honey (20 ml)

1 tbsp Worcestershire sauce
(15 ml)

salt and pepper

scallions, for garnish

fresh cilantro, for garnish

DIRECTIONS

1 Preheat the oven to 300 °F (150 °C). Roughly chop the onion, carrots, and apple, and place in a large roasting pan.

2 In a bowl, combine the paprika, chili powder, sea salt, oregano, thyme, garlic powder, and black pepper.

3 Using a sharp knife, score the pork shoulder. (This means to cut a crosshatch pattern into the top layer of fat.) Rub olive oil all over the meat, then add the spice mixture and make sure every part of the shoulder is covered with the spices. (Be sure to get into the fatty nooks and crannies.)

4 Place the meat on top of the vegetables in the roasting pan, then pour the beer around the pork shoulder and place the pan in the oven. Bake uncovered for 2 hours.

5 Baste the shoulder (this means to spoon the liquids in the bottom all over the exposed part of the pork shoulder), then carefully cover with aluminum foil and continue to bake, covered, for 3 more hours.

6 To make the BBQ sauce, finely dice the onion and jalapeño pepper. In a large saucepan, sauté the onion, pepper, and garlic in olive oil over medium heat.

7 Once the onion is translucent, add the bourbon and cook for 3 minutes. Then add the ketchup, brown sugar, rice vinegar, honey, Worcestershire sauce, and a good pinch of salt and pepper. Stir. Bring the sauce to a boil, then reduce to a simmer and cook for 30 minutes.

8 Once done baking, let the pork cool for 15 minutes. Remove the meat to a sieve and drain the liquids into a separate dish, keeping the juices. Discard the vegetables.

9 Using two forks, break apart the meat into stringy pieces and discard any fat or gristle. Add the strained juices, mix, cover, and keep warm.

10 In a bowl, add the amount of pork that you will eat and mix with as much BBQ sauce as you would like (it's a lot of food, so you may not eat it all). Serve between fresh baguette slices or burger buns with a few chopped scallions, fresh cilantro, and a side of coleslaw (pg 73).

FOR THE BBQ SAUCE

½ white onion

1 jalapeño pepper

3 garlic cloves, minced

1 tsp olive oil (5 ml)

⅓ cup bourbon (80 ml)

1 cup ketchup (235 ml)

TEA PARTY SANDWICHES

SERVES: 2–3

INGREDIENTS

EGG SALAD SANDWICH

2 eggs

1 pickle

fresh dill

¼ cup mayonnaise (60 ml)

salt and pepper

4 slices wheat or grain bread

CUCUMBER SANDWICH

½ large cucumber

fresh chives

a pinch of salt

¼ cup cream cheese
 (60 grams)

¼ cup mayonnaise (60 ml)

4 slices white bread

CHICKEN SALAD SANDWICH

2 celery stalks

fresh parsley

1 can premium chicken breast
 (or leftover chicken breast)

¼ cup mayonnaise (60 ml)

salt and pepper

4 slices wheat or grain bread

FOR THE EGG SALAD SANDWICH:

Boil the eggs for 10 to 15 minutes, then let them cool. Finely slice the eggs, pickle, and chop the fresh dill. Place these ingredients in a bowl. Add the mayonnaise and a pinch of salt and pepper. Stir and refrigerate until ready to assemble.

FOR THE CUCUMBER SANDWICH:

Slice the cucumber thinly and chop the chives. Season the cucumber slices with a pinch of salt and set aside until ready to assemble the sandwich. In a bowl, combine the cream cheese, mayonnaise, and chives. Refrigerate until ready to assemble.

FOR THE CHICKEN SALAD SANDWICH:

Finely dice the celery and fresh parsley and place in a bowl. Strain the can of chicken or, if using leftover cooked chicken, finely chop the meat. Add the mayonnaise, chicken, and a pinch of salt and pepper to the bowl and stir. Refrigerate until ready to assemble.

FOR THE TUNA SALAD SANDWICH:

Finely dice the celery and place in a bowl. Strain the can of tuna. Add the tuna, capers, mayonnaise, and a pinch of salt and pepper. Stir and refrigerate until ready to assemble.

TO ASSEMBLE:

Once the fillings are made and you're ready to serve, spoon the fillings in between the bread. Stack 2 to 3 sandwiches and cut off the crusts, then cut them diagonally in half (so they are all the same size and shape). Serve with tea.

INGREDIENTS

TUNA SALAD SANDWICH
2 celery stalks

1 can tuna (170 grams)

1 tbsp capers (8 grams)

¼ cup mayonnaise (60 ml)

salt and pepper

4 slices white bread

PORK BELLY BAO

SERVES: 4–5

INGREDIENTS

¼ cup salt (55 grams)

¼ cup sugar (55 grams)

1 cup hot water

2 cups cold water

1½ lbs boneless, skinless pork belly

¼ cup chicken stock (60 ml)

4 cloves garlic

½-inch piece ginger, peeled

4 scallions

4 tbsp brown sugar (65 grams)

2 tbsp rice vinegar (30 ml)

½ cup soy sauce (120 ml)

¼ cucumber

fresh cilantro

FOR THE BAO DOUGH

1½ tsp active dry yeast (4¼ grams)

1 cup warm water (240 ml)

2½ cups flour (250 grams)

1½ tbsp sugar (22 grams)

2 tsp baking soda (8 grams)

2 tbsp canola oil (30 ml)

DIRECTIONS

1 To make the brine: In a large bowl, dissolve the salt and sugar in hot water. Add 2 cups of cold water and a few ice cubes. (Make sure the brine is 45 °F [7 °C] or lower. You don't want it to cook the meat.)

2 Cut the pork belly into ¼-inch strips and place in a roasting pan. Pour the brine mixture on top so it covers everything. (You may need to add more water and/or place an object on top of the meat, to keep it submerged.) Cover with aluminum foil and let it soak in the refrigerator overnight.

3 Preheat the oven to 300 °F (150 °C). Discard the brine and add chicken stock to the roasting pan. Cover with aluminum foil and bake for 2 hours.

4 To make the bao dough: In a bowl, combine the yeast and warm water, stir, and let it rest for 15 minutes. In a large bowl, combine the flour, sugar, and baking soda, and mix well. Add the canola oil to the yeast mixture, stir, and then add that to the flour mixture. Stir using a spoon, then knead on a floured surface until the dough is smooth. (Note: You can keep adding flour little by little while kneading, if the dough is too sticky). Roll into a ball and place back in the bowl. Cover the bowl with plastic wrap and let it rise at room temperature for 2 hours.

5 Remove the pork from the oven and let it cool. Then cut it into 1 to 2 inch slices. (It won't look or smell too appetizing, but once you fry it in the sauce, it will be amazing).

6 Take the dough and roll it into a long log and cut into circles about 2½ inches in diameter and ½-inch thick. Roll into an oval, then fold in half.

7 Mince the garlic cloves, ginger, and scallions. Place in a bowl and add the brown sugar, rice vinegar, and soy sauce. Stir.

8 If you have a bamboo steamer, line it with parchment paper and evenly space the bao buns so they don't stick. Steam for 10 minutes. If you don't have a steamer, bring a pot of water to a boil, place a colander on top (make sure the bottom doesn't touch the water) and space the buns evenly in the colander so they don't touch. Cover and steam for 10 minutes.

9 Simultaneously, heat a few teaspoons of olive oil over high heat and wait until the pan is very hot. Carefully add the pork (you may need to cook in batches in order to give each slice enough room) and brown each side. It will sizzle and splatter, so be careful when flipping.

10 Reduce the heat to low and pour the sauce on top. Sauté for 5 to 10 minutes, flipping the pieces of meat once, so both sides are caramelized.

11 Slice the cucumber and remaining scallions, and chop the cilantro.

12 Open the bao bun and add a few slices of the cucumber, the pork belly and sauce, some sliced scallion, and cilantro. Enjoy immediately.

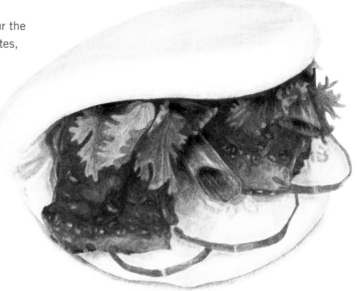

CHICKEN GYRO

SERVES: 2–3

INGREDIENTS

1 lb boneless free-range
 chicken breast (450 grams)

salt and pepper

1 tbsp honey (20 ml)

2 garlic cloves, minced

¼ cup chicken stock (60 ml)

1 tbsp olive oil (15 ml)

1 tsp dried oregano (4 grams)

¼ red or white onion

tomato

a few leaves of fresh lettuce

flat pita bread

FOR THE TZATZIKI SAUCE

1 garlic clove, minced

¼ cucumber

1 cup plain Greek yogurt
 (240 ml)

1 tbsp lemon juice (15 ml)

1 tbsp fresh or dried dill
 (12 grams)

1 tsp white wine vinegar (5 ml)

salt and pepper

DIRECTIONS

1 Slice the chicken breast into strips and season both sides with salt and pepper.

2 In a bowl, combine the honey, garlic, chicken stock, olive oil, and dried oregano. Stir well.

3 Add the chicken to the marinade and refrigerate for 1 hour.

4 To make the tzatziki sauce, mince the garlic and finely dice the cucumber. Place in a bowl. Add the Greek yogurt, lemon juice, dill, white wine vinegar, a pinch of salt and pepper, and stir.

5 Chop the onion, slice the tomato, and shred the lettuce into strips.

6 Heat a large pan over high heat and wait until it's very hot.

7 Using tongs, place the chicken on the pan (leaving the marinade juices in the bowl). Brown each side (flipping only once), then reduce the heat to medium low. Add the marinade juices and half of the onion. Cook for 3 to 5 minutes and season with salt and pepper.

8 Warm the pita bread in a small pan or microwave to make it flexible.

9 To assemble, add the onion, tomato, lettuce, chicken, and a few spoonfuls of tzatziki sauce on top, then fold over.

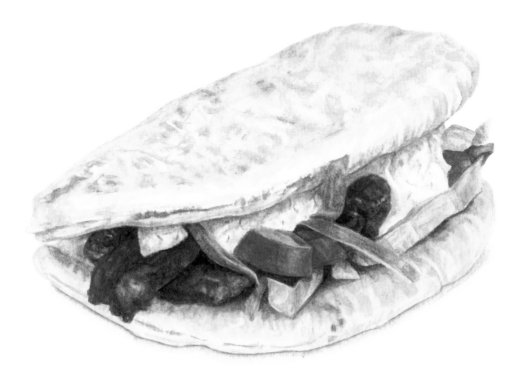

NOTE Traditionally, this is made with meat cooked on a vertical skewer for hours at a time on street corners and enjoyed by people at 3 a.m. on the way back from a concert. To get that same deliciously greasy taste, add some extra-virgin olive oil to the pan and scrape up any browned bits from the pan to add to the pita bread.

SOUPS

FOR YEARS, SOUPS WERE A HUGE MYSTERY FOR ME. I ALWAYS LOVED THEM, ESPECIALLY THE creamy versions, but the idea of making them from scratch was intimidating. I had imagined they were insanely complex and assumed I would screw it up. But when I actually saw my mother-in-law, Basia, make a tomato soup from scratch in 45 minutes, I was amazed.

Seeing the simplicity of soup-making stirred me. Suddenly, many of the foods I had assumed were impossible for an amateur were within my reach. It broke down my idealization of chefs and gave me the courage to roll up my sleeves and cook.

Of course, I didn't master anything overnight. I saw Basia make that soup years before I started to seriously dabble in the world of stocks and stews, but that awe stayed with me and was one of the reasons why I chose to learn to cook. If generations of grandmothers and mothers could do it, maybe it was high time for me to master the art too.

I started making chicken noodle soup using bouillon cubes or store-bought canned/boxed stocks. There's absolutely nothing wrong with starting there—in fact, I recommend it, especially if time is a factor for you. After you get comfortable with this method, you can move on to making your own stock too.

My first few tries weren't pretty, but they tasted a hundred times better than the canned options. This is what I did! Bring a medium-sized pot of water to a boil. Add the bouillon cubes (check the package for the correct ratio; however, I usually used ½ cube more than what was specified for more flavor), then reduce to a simmer. Chop an onion in half, peel 1 clove of garlic, roughly cube 2 carrots and 2 potatoes, and add it all to the pot. Then add 3 to 4 allspice berries, a bay leaf, a pinch of salt, some cooked, shredded chicken, and stir. Let it simmer for 30 minutes or until the potatoes are cooked.

Taste the broth to see if you need more salt. Then discard the bay leaf, allspice, and onion (these are just flavor enhancers), make some pasta separately, and serve the soup hot over the pasta. Please note that if you cook the pasta in the soup, it will absorb all the liquids and become giant, soft noodles if there are leftovers (just like the canned versions). So factor in the absorption rate and add a bit more water.

The magical thing about soups is that you can easily transform one into another by

adding a few simple ingredients. For example, if I wanted a creamy potato soup, I'd remove the carrots, add 2 to 4 tablespoons heavy cream once it was done cooking, stir, and serve. If I wanted a thicker potato soup, I'd also add a roux.

Don't be afraid, a roux is very simple. You take a small pan, melt 2 tablespoons of butter over medium heat, then quickly stir in 2 tablespoons of flour until it becomes a thick and even paste. This happens quickly and you don't want to burn it, so pay attention. You can add more flour for a thicker roux, but I like the 1:1 ratio. Remove it from the heat, add some of the soup liquids to the roux and stir (this helps remove any clumps), and then add it to the soup while it simmers. Stir, then give it 5 minutes, and it should thicken up nicely.

Let's say you want a tomato soup instead. Take 4 to 8 tablespoons of tomato paste (depending on how tomato-y you want it) and place it in a cup. Add some of the chicken noodle soup liquids to the cup and stir, using a spoon, until the tomato paste is dissolved and well combined. Add this to the soup, simmer for 5 minutes, and it's done. For a creamy tomato soup, add 2 to 3 tablespoons heavy cream after simmering, stir and serve.

For a very Polish soup, try making a pickle soup. The key here is to buy the kosher dill pickles in brine found in the refrigerated section, not the sweet kind! When you're adding the carrots and potatoes, grate 2 to 3 of these pickles into the soup and add ¼ cup of the pickle brine to the soup. Bring to a boil, then simmer until the potatoes are tender.

Once you get the hang of that, you can try adding more flavorful herbs like fresh parsley, dill, basil, thyme, etc. You can add them in the beginning of the soup-making process for a less pronounced taste, or at the end for a brighter, more acute flavor. It's crazy simple and infinitely flexible. Here are some other soup recipes to expand your soupertoire.

A TALE OF THREE STOCKS

Vegetable, chicken, and beef stocks are hugely important when cooking and incredibly simple to make. These flavor condensers form the base for many delicious dishes and are an essential part of making soups. After a lot of trial and error, here are my foolproof stock recipes.

VEGETABLE STOCK

A vegetable stock is the quickest to make because you want to keep the flavors crisp—cook for too little time and you won't get as much flavor, but cook for too long and it will taste dull and overdone.

TIP: For a deeper savory flavor, try roasting the vegetables at 400 °F for 30 to 45 minutes (make sure they don't char), then continue on to step 2.

INGREDIENTS

1 garlic clove

4 carrots

2 parsnips

½ celeriac root

1 onion

1 leek

2 bay leaves

5 black peppercorns

3 allspice berries

3 dried mushrooms

1 tsp salt

8½ cups water

1 Peel the garlic and roughly chop the carrots, parsnips, celeriac, onion, and leek into large chunks. Thoroughly wash and place in a stockpot.

2 Add the bay leaves, peppercorns, allspice, dried mushrooms, salt, and enough cold water so all the ingredients are submerged (about 2 quarts). Cover the pot with a lid and bring to a simmer.

3 Once you see small bubbles, remove the lid and cook for 30 minutes.

4 Remove the large vegetable chunks and strain the stock using cheesecloth.

CHICKEN STOCK

If you only learn one thing from this book, let it be this recipe! A chicken stock is the mother of so many amazing recipes. I just can't express how important it is.

TIP: To be more economical, what I like to do is roast a chicken for dinner, then, the day after, use any leftover meat and the chicken carcass to make a stock. It will taste slightly different than the recipe below, since the chicken is roasted and there is less meat, so add more vegetables and herbs and reduce the cooking time in step 5 to 3 hours (max).

1 Wash and clean the chicken and vegetables. Cut the onion in half and chop the carrots and celery so they fit in the pot, or keep whole. Separate out the chicken breasts.

2 Place the chicken, onion, carrots, celery, and garlic in a large pot and cover with cold water so everything is submerged. Bring it to a boil, then immediately lower to a simmer.

3 Remove any foam that comes to the surface, and add salt, peppercorns, and the bouquet garni, and simmer for 1 hour.

4 Remove the chicken breasts for dinner or leave in the pot for a more flavorful stock.

5 Continue to simmer for 4 to 5 hours (max). Stir, taste, and season with additional salt lightly at hourly intervals.

6 Remove the chicken and vegetables and strain the broth using a cheesecloth. Let it cool completely before placing it in the refrigerator. The fat will separate and create a thick layer on the top. Scrape that off and it's ready to use or store.

INGREDIENTS

1 whole chicken

1 onion

3 carrots

3 celery stalks

3 garlic cloves

8½ cups water

½ tsp coarse salt

½ tsp peppercorns

2 sprigs fresh parsley

2 sprigs fresh rosemary

2 sprigs thyme

1 bay leaf

(place the herbs in a cheese-cloth and tie with a string—this is called a bouquet garni and will be easier to add/remove.)

BEEF STOCK

Similar to a chicken stock, a beef stock can add a lot of amazing depth to sauces, gravies, and soups. Whether you use only the bones or the meat with the bones, it's crucial that you don't leave the stock at a roaring boil. It should boil just to get things going, then immediately be reduced to a simmer. The reason for this is that when you simmer the stock, the scum (which consists of congealed proteins) and fat will rise to the surface where they can be skimmed off. If boiled for a long time, the scum will emulsify and make the stock cloudy and greasy in taste.

TIPS: To get more out of this stock, you can use a large chunk of beef shank (with the bone) instead of just the bones. This will create a richer taste, and you can eat that meat for dinner.

INGREDIENTS

1 onion

2 carrots

1 celeriac root

1 parsnip

6 garlic cloves

extra-virgin olive oil

2½ lbs beef bones (preferably with some meat)

8½ cups water

1 large parsley bunch

a few sprigs fresh thyme

1 bay leaf

1 tsp black peppercorns

2 tsp salt (optional)

1 Preheat the oven to 450 °F.

2 Roughly cut all the vegetables into 3-inch pieces.

3 Place the bones and vegetables in a large roasting pan and drizzle with some olive oil, then roast for 30 minutes, turning the bones once at the 15-minute mark.

4 Pour everything into a large pot. Be sure to scrape those browned bits off the pan too (you may need to add some hot water to dislodge them).

5 Add cold water to the stockpot so everything is covered. Also add the parsley, thyme, bay leaf, and peppercorns. Bring to a boil, then reduce to a simmer. Cook for 5 hours, skimming off any fat or foam (at hourly intervals). Add salt to taste.

6 Strain through cheesecloth and use or refrigerate. There will be a layer of fat once chilled, so remove that before freezing or cooking with the stock.

Storage/Other

Stocks store really well, but make sure they have cooled completely before placing in containers in the refrigerator or freezer. These stocks can be stored in the refrigerator for 1 week, or in the freezer for 6 months.

To Freeze: Once cooled, pour into ice cube trays or muffin pans and place in the freezer for 1 day. Remove from containers (you may need to place in a bowl of hot water to loosen), then transfer to Ziploc bags and place back in the freezer. (Note: It might be a good idea to get a separate ice cube tray, because stock-flavored ice cubes are gross.)

Bouillon Cubes/Concentrates: These quick, store-bought options are convenient and come in cube or liquid form. Just add boiling water to the ratio of bouillon you are using (see package), stir, and you have a stock. However, bouillon cubes and concentrates typically contain a high amount of salt because they are dehydrated and can have additives that are probably not the healthiest, so read the label beforehand.

Emergency Fixes

Too Bland: This can happen when there's too much water or too little salt. To fix, bring the stock to a boil, add a pinch of salt and reduce slowly. Taste every 15 minutes and add salt a pinch at a time. (Note: It's OK for a homemade stock to be less salty than the store-bought kinds because you will likely season it again, once you use it in a soup or sauce).

Too Salty: Add more water or try adding some acid (like lemon or vinegar) or sugar. You can also add some pasta and/or potatoes to absorb some of the salt.

Too Sweet: Try adding some salt or 1 teaspoon of apple cider vinegar or white vinegar. Be sure to taste after each addition.

Too Bitter: This can happen to stews with beer or if you add too much lemon. To fix, bring to a boil for a few minutes and see if it evaporates out. Then try adding some salt, sugar, or garlic.

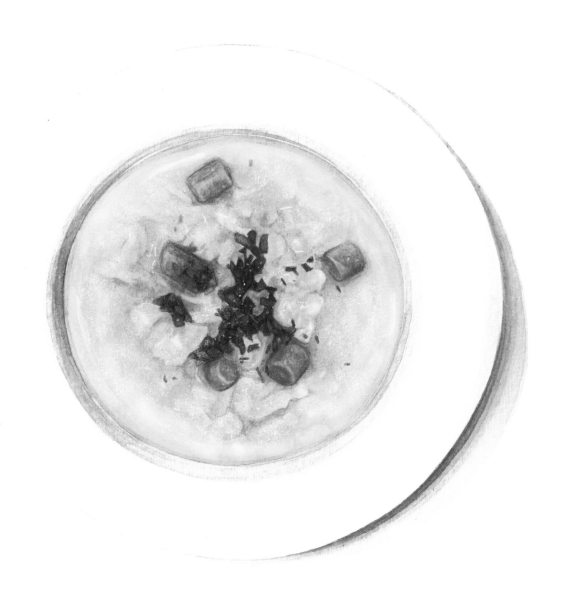

CHICKEN NOODLE SOUP

SERVES: 2-3

DIRECTIONS

1 Peel the carrots and potatoes and chop them into similar-size chunks. Cut the onion in half.

2 In a large pot over high heat, add the chopped vegetables and chicken stock (see pg 103) and bring it to a boil, then lower to a simmer. If using bouillon cubes, fill the pot with 6 cups of water and bring to a boil, then add the cubes and stir until dissolved. (Check the package for the correct bouillon:water ratio.)

3 Taste and season with salt and pepper, then simmer for 30 to 45 minutes.

4 Bring a small pot of water to a boil.

5 In a bowl, combine the flour and eggs and mix well until there are no lumps.

6 Slowly pour the batter into the boiling water until all the batter is used, forming long, noodle-like strings. Stir, then strain the egg noodles.

7 Place the egg noodles in a bowl, then add the soup and garnish with freshly chopped parsley. Season with salt and pepper to taste.

INGREDIENTS

2 carrots

2 potatoes

1 onion

6 cups chicken stock (1.4 L) or bouillon cubes

salt and pepper

1 cup flour (128 grams)

2 eggs

1 sprig fresh parsley

NOTE As a well-known remedy for all sniffles and colds, this recipe will keep you hydrated—it has electrolytes. The handmade noodles are very quick and easy, so you can get back to that couch or bed if you have to make it for yourself.

PASTA FAGIOLI

SERVES: 3–4

DIRECTIONS

1 Finely chop the bacon or pancetta and the yellow onion. Mince the garlic.

2 In a large pot, heat olive oil over medium-high heat and sauté the bacon, onion, and garlic. Stir and cook for 5 to 8 minutes.

3 Add the can of tomatoes, sage, red pepper flakes, and bay leaf. Season with salt and pepper. Simmer for 20 minutes.

4 Rinse the cannellini beans thoroughly and add to the soup. Then add the chicken stock and continue to simmer for 30 minutes.

5 Add the pasta and cook until soft.

6 Ladle and serve with freshly grated Parmesan cheese and chopped parsley.

INGREDIENTS

3 slices bacon/pancetta

1 yellow onion

2 garlic cloves

1 tsp olive oil (5 ml)

1 can (28 oz) chopped tomatoes (0.8 L)

1 tbsp dried sage (12 grams)

a pinch of red pepper flakes

1 bay leaf

salt and pepper

1 can (14 oz) of cannellini beans (0.4 L)

4 cups chicken stock (1 L)

½ cup of ditalini pasta (125 grams)

Parmesan cheese

1–2 sprigs fresh parsley

NOTE In Italian this soup is called *pasta e fagioli,* which means "pasta and beans." It is traditionally a meatless dish, but I like to use bacon or pancetta to add a robust, smoky taste and increase the amount of protein. A perfect dish for cold, rainy days, since tomatoes are rich in antioxidants. And like most soups, it tastes better the day after.

LEEK & POTATO SOUP

SERVES: 4

DIRECTIONS

1 Wash and dice the leeks, red bell pepper, and potatoes. Cut the corn off the cob.

2 In a large pot, heat the butter and olive oil over medium-low heat.

3 Add the diced leek and cook for 5 minutes.

4 Add the red bell pepper and cook for 3 minutes.

5 Add the chicken stock, potatoes, corn, bay leaf, oregano, and a few pinches of salt and pepper.

6 Bring to a boil, then reduce to a simmer for 30 minutes.

7 Taste and season with salt and pepper.

8 Add heavy cream, stir, and remove from the heat.

9 Add some chopped chives and serve.

INGREDIENTS

2 leeks

1 red bell pepper

3–4 potatoes

1 corn cob

1 tbsp butter (14 grams)

1 tbsp olive oil (15 ml)

6 cups chicken stock (1.4 L)

1 bay leaf

½ tsp dried oregano (2 grams)

salt and pepper

¼ cup heavy cream (60 ml)

fresh chives

NOTE To wash the leeks, rinse off any surface dirt, then chop off the root. Cut each leek lengthwise and rinse away any dirt in between each of the leaves. For especially dirty leeks, dice them, then place them in a bowl of cold water and rub clean to dislodge any remaining dirt. Remove the cleaned leeks using a sieve or your hands.

POLISH BEET SOUP

SERVES: 2–3

INGREDIENTS

a handful of dried mushrooms

2 cups cold water

2 bay leaves

2 cloves of garlic

6 cups vegetable stock (1.4 L)

4–5 beets

2 tbsp oregano (24 grams)

6 black peppercorns

4 allspice berries

salt and pepper

¼ lemon

fresh parsley

eggs, tortellini, or baby potatoes
 (optional)

sour cream (optional)

DIRECTIONS

1 Rinse a handful of dried mushrooms and place in a bowl. Add cold water, bay leaves, and cloves of garlic, and leave to soak overnight.

2 Bring the vegetable stock (see pg 102) to a boil in a large pot.

3 Wash, peel, and dice the beets into large cubes and add to the vegetable stock.

4 Season with oregano, peppercorns, allspice, and a pinch of salt and pepper. Reduce to a simmer, cover, and cook for 30 to 40 minutes, or until the beets are tender.

5 Place the soaked mushrooms in a small pot with the water they were soaked in and bring to a boil. Reduce to a simmer for 15 minutes or until soft. Strain the stock, keeping both the mushrooms and the liquid separate. Discard the bay leaves and garlic.

6 Turn off the heat, remove the beets with a strainer or ladle, and add the mushroom stock. In a small cup, squeeze the lemon and slowly add to the soup one teaspoon at a time, stirring and tasting to see if you want more or less. (You may not need that much.)

7 Chop the mushrooms and beets, and a handful of fresh parsley, then add back to the soup.

8 Bring a pot of water to a boil and cook the eggs, tortellini or baby potatoes and serve with the soup. You can add a dollop of sour cream for a richer taste.

CHICKEN CORN SOUP

SERVES: 2

DIRECTIONS

1 Cut the chicken breast into small cubes and season with salt and pepper.

2 Bring the chicken stock to a boil.

3 Add the chicken to the boiling stock and cook for 15 minutes.

4 Finely dice the corn into smaller pieces and add to the soup. Continue to boil for 2 to 3 minutes, and reduce to a simmer.

5 In a small bowl, combine the soy sauce and cornstarch. Stir the soup while adding this mixture.

6 In a bowl, beat the eggs. Stir the soup, creating a whirl-pool, and slowly pour in the eggs while continuing to stir. This will create fine threads.

7 Chop the scallions and add to the soup. Cook for 2 minutes.

8 Season with pepper and a few drops of sesame oil in each bowl (optional) and serve.

INGREDIENTS

1 free-range chicken breast

salt and pepper

5 cups chicken stock (1.2 L)

1 cup fresh or canned corn (120 grams)

2 tbsp soy sauce (30 ml)

1 tbsp cornstarch (12 grams)

2 eggs

2 scallions

½ tsp sesame oil (7 ml)

NOTE This is one of my favorite quick soups to make at home. From beginning to end, it takes 45 minutes. You don't have to chop the corn, but I like to chop it because it adds a creamy texture. Feel free to replace the chicken with tofu or remove it all together. You can also replace the chicken stock with vegetable stock.

HEARTY BEEF STEW

SERVES: 2–3

INGREDIENTS

1 onion

2 carrots

3 large potatoes

1½–2 lbs beef chuck (1 kg)

salt and pepper

½ tsp olive oil (3 ml)

8 cups beef stock (2 L)

1 tbsp tomato paste (14 grams)

2 cloves crushed garlic

½ tsp dried thyme (2 grams)

½ tsp dried oregano (2 grams)

¼ tsp salt (1 gram)

1 bay leaf

3 peppercorns

1 cup fresh or frozen peas (230 grams)

⅛ cup cornstarch (30 grams)

fresh baguette

DIRECTIONS

1 Dice the onion, carrots, and potatoes into 1-inch cubes.

2 Wash the beef and pat the meat dry using paper towels (this is very important). Cut the meat into cubes and season all sides with salt and pepper.

3 Heat olive oil in a large pan over high heat. Once the oil is very hot, add the beef and sear all of the sides (you will need to do this in batches so the meat doesn't touch and stick together), then remove it to a plate to cool.

4 In the same pan, sauté the onion and carrots until lightly browned, then remove and place in a bowl.

5 Deglaze the pan using some of the beef stock and pour the fond into a soup pot. Add the rest of the beef stock, tomato paste, crushed garlic cloves, thyme, oregano, salt, bay leaf, peppercorns, and the cooked beef, then bring to a boil.

6 Reduce to a simmer and cook for 2 hours.

7 Add the vegetables and taste. Season very lightly with salt. (Note: Use less salt than needed because the liquids will reduce.) Cook for 30 to 45 minutes, or until the potatoes are tender.

8 Add the frozen or fresh peas.

9 In a cup, mix the cornstarch with some of the soup until there are no lumps. Add to the soup and cook for 10 minutes.

10 Serve with a fresh baguette.

NOTE Searing the meat on all sides is essential because it adds a huge amount of flavor. It also creates "fond" (pronounced "fahn"), which are the little caramelized bits of charred meat stuck to the pan. To incorporate them into the soup, you "deglaze" the pan using liquid and heat to dislodge them from the bottom (step 5).

TOMATO SOUP

SERVES: 4

DIRECTIONS

1 In a blender, combine the canned tomatoes, onion, and garlic. Blend until smooth. (This will look pink. That's okay, it will redden as it cooks.)

2 Pour the tomato mixture into a large pot and bring to a boil.

3 Add 1 tablespoon of olive oil and season with a pinch of salt and pepper. Stir, then reduce to a simmer and cook for 30 minutes.

4 Add the heavy cream, stir, and cook for 10 minutes. (Make sure it doesn't boil.)

5 Chop the baguette into cubes.

6 Heat the remaining olive oil over medium heat and add the cubed baguette. Fry until golden and serve with the soup.

INGREDIENTS

2 cans (28 oz each) whole peeled tomatoes

1 white onion, chopped

1 garlic clove, minced

2 tbsp extra-virgin olive oil (30 ml)

salt and pepper

¼ cup heavy cream (60 ml)

fresh baguette

NOTE This soup doesn't get much simpler! Thick in texture, you can also use this as a tomato sauce if you have a small amount left. It's just too good to throw out. It will keep in an airtight container in the refrigerator for up to 2 days.

CREAM OF BROCCOLI

SERVES: 2

DIRECTIONS

1 Finely dice the onion and broccoli and mince the garlic.

2 Heat the olive oil in a soup pot over low heat and sauté the onion and minced garlic for 5 minutes.

3 Add the chicken broth and bring to a simmer.

4 To make a roux, melt butter in a pan over medium-high heat and add the flour. Using a whisk or spoon, stir the butter and flour until a thick and even paste forms.

5 Add the roux to the soup and stir until well-combined.

6 Slowly add the milk and heavy cream.

7 Add the diced broccoli and season with salt and pepper to taste.

8 Add the shredded cheddar cheese and simmer for 10 minutes.

9 Serve with a few sprinkles of shredded Cheddar cheese and season to taste.

INGREDIENTS

½ white onion

2 cups broccoli (1 head broccoli)

1 garlic clove, minced

1 tbsp olive oil (15 ml)

3 cups chicken broth (0.75 L)

5 tbsp butter (70 grams)

½ cup flour (65 grams)

½ cup milk (120 ml)

½ cup heavy cream (120 ml)

salt and pepper

1 cup shredded cheddar cheese (235 grams), plus additional shreds for serving

NOTE The soup will be light and watery until you add the roux. You will be surprised at just how thick the soup will become once you add this, so add slowly until you like the consistency.

ANJA'S SPINACH SOUP

SERVES: 4

DIRECTIONS

1 Boil the rice in 2 cups of chicken stock until cooked, then let it cool completely.

2 Chop the onion and sauté in canola or vegetable oil over medium heat in a large pan.

3 Add the spinach and cook for 5 to 8 minutes until the spinach has wilted.

4 Let the spinach cool completely.

5 In a blender, add the cooked onion and spinach, 2 cups chicken stock, ½ cup cooked rice, heavy cream, lime juice, and a few shakes of salt and pepper. Blend until smooth.

6 Pour the soup in a soup pot and bring to a boil, then reduce to a simmer and cook for 15 minutes.

7 In a bowl, place a scoop of rice, then add the spinach soup on top. You can add a few drops of heavy cream (optional) and serve immediately.

INGREDIENTS

1 cup rice (235 grams), divided

4 cups chicken stock (1 L)

1 small white onion (or ½ large onion)

1 tsp canola or vegetable oil (5 ml)

4 cups tightly packed fresh spinach (200 grams)

½ cup heavy cream (120 ml)

1 tbsp lime juice (15 ml)

salt and pepper

NOTE One of my best friends, Anja, made this for dinner when I visited her in Germany. I was quietly scared to eat it—it was sooo green! After I took my first spoonful, I was hooked. The rice balances the dense, rich taste, and adds great texture, but be warned—it's very filling.

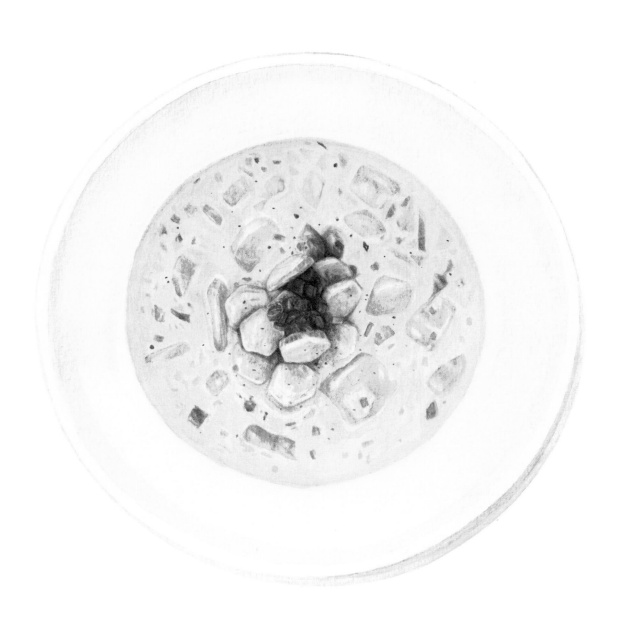

CLAM CHOWDER

SERVES: 4

DIRECTIONS

1 Finely dice the onion, carrot, and celery. Cut the potatoes into cubes.

2 Sauté the onion, carrot, and celery in 3 tablespoons of butter and olive oil over medium-low heat for 5 minutes.

3 Strain the clams, reserving the clam juices, and add the juices to the sautéed vegetables. Reduce the heat to low and cook for 10 to 15 minutes. Put the clams aside for the moment.

4 In a pot, melt ½ cup butter over medium heat and whisk in the 2 cups of milk and 2 cups of heavy cream until smooth.

5 Add the vegetables with the clam juice to the pot and stir. Cook over medium heat for 5 minutes.

6 Stir in the clams and cook for 10 minutes.

7 In a cup, combine the flour with a few ladles of soup and whisk until smooth. Then add to the soup and stir. Continue to simmer for 10 minutes. Season with salt and pepper.

8 Serve with freshly chopped chives and oyster crackers.

INGREDIENTS

½ white onion

2 carrots

3 celery stalks

2–3 potatoes

½ cup + 3 tbsp butter (155 grams)

3 tbsp extra-virgin olive oil (45 ml)

3 cans (6.5 oz each) of chopped clams (0.18 kg each)

2 cups milk (480 ml)

2 cups heavy cream (480 ml)

⅓ cup flour (43 grams)

salt and pepper

chives

oyster crackers

NOTE Making clam chowder from scratch is not as difficult as you would think. Unlike the restaurant versions, this soup has a slightly sweet and unique taste (thanks to the carrots) that I've yet to find in a restaurant.

SMALL PLATES

EVERY HERO NEEDS A SIDEKICK. YOUR AMAZING THANKSGIVING TURKEY IS ONLY AS GOOD AS the sides you serve with it. And, well, who wants a meal of just meat or tofu and nothing else? Whether you're completing a dinner or enjoying a small meal, this is the ideal place to experiment with your taste palette and to try new spices, sauces, cooking methods, and vegetables. Not only will you minimize the cost and risk of the inevitable mistakes and "dislike" trials that are a part of learning, but cooking sides is a way to branch out from the boiled, steamed, or microwaved options.

I began by choosing my favorite vegetables: asparagus, mushrooms, potatoes, spinach, beans, etc., and learned how to cook them as simply as possible, seasoned with only a little salt and pepper. This way I discovered each vegetable's natural flavor and texture. And surprisingly, once I did that, I realized that most vegetables taste their best when they are fresh and barely cooked.

I had been overcooking my sides, which dulled the natural flavors and destroyed the unique textures. For example, each potato variety has a distinctly different taste and texture, but this is hard to notice in a mash, due to all the salt and creamy butter. What really got me excited about sides was going to farmers' markets and buying the things I had never tried cooking before. I'd see such beautiful and unique vegetables— misshapen, colorful, and some that I couldn't get at any grocery store. Things like zucchini flowers, purple or white asparagus, blue potatoes, rainbow carrots, Romanesco, sunchokes, dandelion greens, kohlrabi, ramps, kumquats, dragon fruit, marionberries, and—my favorite—heirloom tomatoes.

As I became more in-tune with farmers' markets, I started noticing the seasons of vegetables and fruits. In America, we're incredibly lucky to have all the vegetables and fruits available year-round. In the vast majority of the world, food is sold seasonally. You know how I mentioned how shocked I was that food was so cheap when I backpacked in Europe? Well, that's because they don't have to import food or factor in the huge cost of waste created by selling out-of-season veggies.

There are seasons for everything. Learning when food is at its ripest is essential to making the best, most flavorful dish that you can. Buying in season is cheaper, health-

ier (fresher = more nutrients), better for the economy (no importing = less waste), and frankly, tastes way better! Seriously, there's a huge difference between a straight-from-the-vine veg and one that's been sitting in a carton or bag for a few months. Here are the best times to buy most vegetables and fruits in the US.

WINTER
Fruits: Apples, Lemons, Limes, Oranges, Pears, Persimmons, Pomegranates, Quinces
Vegetables: Beets, Brussels Sprouts, Celeriac Root, Collard Greens, Endive, Escarole, Fennel, Frisée, Kale, Leeks, Parsnips, Potatoes, Sunchokes, Sweet Potatoes, Turnips, Winter Squash

SPRING
Fruits: Avocados, Bananas, Coconuts, Kiwis, Mangoes, Lemons, Limes, Oranges, Papayas, Passion Fruit, Pineapples, Strawberries, Tangerines
Vegetables: Artichokes, Arugula, Asparagus, Beets, Broccoli, Cauliflower, Chives, Fava Beans, Fiddleheads, Green Beans, Kale, Lettuce, Onions, Peas, Radicchio, Radishes, Ramps, Rhubarb, Scallions, Sorrel, Spinach, Swiss Chard, Watercress

SUMMER
Fruits: Avocados, Blackberries, Blueberries, Cantaloupes, Cherries, Grapes, Guavas, Honeydew Melons, Mangoes, Nectarines, Peaches, Plums, Raspberries, Strawberries, Tomatillos, Tomatoes, Watermelons
Vegetables: Cabbage, Carrots, Celery, Collard Greens, Corn, Cucumbers, Eggplant, Garlic, Green Beans, Okra, Peas, Peppers, Potatoes, Radicchio, Radishes, Shallots, Summer Squash, Zucchini

FALL

Fruits: Apples, Cranberries, Figs, Grapes, Pears, Persimmons, Pomegranates, Quinces
Vegetables: Broccoli, Brussels Sprouts, Cabbage, Cauliflower, Daikon, Endive, Eggplant, Fennel, Frisée, Garlic, Ginger, Kohlrabi, Leeks, Parsnips, Peppers, Potatoes, Pumpkins, Shallots, Sweet Potatoes, Swiss Chard, Turnips, Winter Squash

The recipes included in this section are my foolproof, favorite small plates. I'm proud to bring these dishes to potlucks or BBQs or eat by myself. Here are my go-to sides.

THE SIDE SHOW

GRAINS: So, what are grains, really? Well, grains are seeds. All grains have three parts: the endosperm, bran, and germ. Whole grains (like wheat, quinoa, barley, brown and wild rice) contain all three parts. However, some grains have been refined to remove part of the whole seed, and are therefore less nutritious.

For example, wheat and white flour are made by grinding the same seed (a wheat berry), but wheat flour has all three parts, while white flour uses only the endosperm (making it white). Same with brown and white rice—brown rice includes all three parts, white rice is only the endosperm.

What's the deal with gluten? Gluten is a protein found in wheat, barley, and rye. It acts like a glue, giving breads elasticity and pastas a chewy texture. It is problematic for people with Celiac Disease because eating it can damage their small intestines. Some people also have a sensitivity to it or have become intolerant to it (due to gluten's wide availability and presence in many products). There are now alternatives such as quinoa and rice-based products, so check them out and eat a variety of grains for a balanced diet.

How to Cook: Grains can be cooked by placing them in water and simmering until tender. I prefer to bring the grains and water to a boil, then reduce to low heat, covering and cooking based on individual cook times. The amount of water needed and cook time varies for each grain, but you can speed up the process by presoaking the grains right before cooking. If the grain is not the right texture or it's too firm, add some more water and continue cooking to your preference. After cooking, I always like to fluff the grains using a fork, so it's not a solid brick after it cools.

Note: There are also precooked or instant grain options available at most grocery stores, if time is an issue.

COOK TIMES

Here are some grain:water ratios and cook times.

(Bring to a boil, then lower to a simmer and cook for . . .)

Pasta — 1 cup:4 to 6 cups water — 10 to 15 minutes, drain
White Rice — 1 cup:1½ cups water — 15 minutes
Brown Rice — 1 cup:2½ cups water — 45 minutes
Basmati Rice — 1 cup:2 cups water — 20 minutes
Jasmine Rice — 1 cup:1¾ cups water — 20 minutes
Wild Rice — 1 cup:3 to 4 cups water — 45 minutes to 1 hour
Quinoa — 1 cup:2 cups water — 15 minutes
Israeli Couscous — 1 cup:2 cups water — 10 to 12 minutes, drain
Couscous — 1 cup:1¼ cups water — 5 minutes
Pearl Barley — 1 cup:3 cups water — 50 to 60 minutes
Steel-cut Oats — 1 cup:3 cups water — 20 to 30 minutes
Polenta — 1 cup:3 cups water — 5 to 10 minutes
Hulled Millet — 1 cup:2 cups water — 20 minutes
Bulgur — 1 cup:2 cups water — 10 to 12 minutes
Farro — 1 cup:3 cups water — 30 minutes
Amaranth — 1 cup:3 cups water — 20 minutes

Legumes: A legume is the seed (and pod) of a plant in the *Leguminosae* family. The most common legumes are any type of pea or bean, lentils, peanuts, alfalfa, and many more. They are a great source of protein and fiber, and are sometimes sold fresh (peas), but are most likely to be found in the dried or canned state. I just couldn't have a small plates section without talking about them, so here are some notes on these versatile and awesome edibles.

Dried Legumes: This is a very economical option, but requires some prep work. Most dried varieties need to be soaked and rehydrated before cooking. First sort through them for any broken or discolored legumes, then rinse them thoroughly.

It's a good standard to soak the legumes in four times the amount of water (so 1 cup legumes + 4 cups water). As for the time needed to soak, this varies, but I always soak overnight to ensure that the legumes are fully hydrated.

After they're soaked, strain and rinse the legumes again, thoroughly! This part is

important because it removes enzymes that can cause gas, and of course, any dirt. At this point you can cook your beans.

However, there is a way to further de-gas your beans. Before soaking, put them in a large pot with five times the amount of water (so 5 cups water:1 cup legumes, for example). Bring the pot to a boil, then turn off the heat, cover, and let the legumes soak for 2 to 8 hours. Then strain and rinse them thoroughly again! Now, finally, you can cook them until they are tender, without any fear of flatulence.

STOVE-TOP COOK TIMES FOR SOAKED, DRIED LEGUMES

Here are some legumes:water ratios and cook times.

(Bring to a boil, then lower to a simmer and cook for . . .)

Black Beans — 1 cup:3 cups water — 1½ hours

Cannellini Beans — 1 cup:4 cups water — 1½ hours

Garbanzo Beans — (no soak) 1 cup:4 cups water — 2 hours

Fava Beans — 1 cup:3 cups water — 45 minutes

Kidney Beans — 1 cup:4 cups water — 1½ hours

Lima Beans — 1 cup:4 cups water — 1 hour

Mung Beans — (no soak) 1 cup:3 cups water — 30 minutes

Navy Bean — 1 cup:4 cups water — 1½ hours

Pinto Beans — 1 cup:4 cups water — 1½ hours

Adzuki Beans — 1 cup:3 cups water — 1 hour

Anasazi Beans — 1 cup:3 cups water — 1 hour

Soy Beans — 1 cup:3 cups water — 3 hours

Small Red/Chili Beans — 1 cup:4 cups water — 1½ hours

Flageolet Beans — 1 cup:4 cups water — 1 hour

Great Northern Beans — 1 cup:3 cups water — 1½ hours

Green Split Peas — (no soak) 1 cup:3 cups water — 30 minutes

Yellow Split Peas — (no soak) 1 cup:3 cups water — 30 minutes

Brown Lentils—(no soak) 1 cup:3 cups water — 20 minutes

Green Lentils — (no soak) 1 cup:2½ cups water — 25 minutes

Red or Yellow Lentils — 1 cup:3 cups water — 15 minutes

SAUTÉED MUSHROOMS

SERVES: 1

DIRECTIONS

1 Peel and mince the shallot and garlic. Slice the mushrooms.

2 Using a damp paper towel, gently wash the mushrooms and pat dry.

3 Wash the parsley and pat dry.

4 In a large skillet, fry the shallot and garlic in butter over medium-low heat for 2 to 3 minutes.

5 Turn the heat up to high and add the mushrooms. Season with salt and pepper and cook for 3 to 5 minutes, tossing once.

6 Add the parsley, stir, and serve immediately.

INGREDIENTS

1 shallot

1 garlic clove, minced

3 giant shiitake mushrooms

a handful of fresh parsley

3 tbsp butter (42 grams)

coarse salt and pepper

NOTE When sautéing, you want to spread the mushrooms evenly in the pan so they are not overlapping. You also want to hear a gentle sizzle while they are cooking, which is the sound of the moisture in them evaporating, so they can caramelize. If you notice them becoming watery, just raise the heat until they sizzle.

ASPARAGUS & EGG

SERVES: 1

INGREDIENTS

handful of asparagus

1 tbsp olive oil (15 ml)

coarse salt and pepper

1 tsp butter (5 grams)

1 egg

1 lemon wedge

DIRECTIONS

1 Clean the asparagus and cut off the bottom 1 to 2 inches of the stems (which can be hard and stringy).

2 Heat a large pan with olive oil over medium heat and add the asparagus. Season with salt and pepper and toss for 3 to 5 minutes, so all sides are cooked.

3 In a separate small pan, heat butter over medium heat and crack an egg, being careful not to break the yolk. Cover with a lid and reduce the heat to low. Cook for 3 to 5 minutes to desired runniness.

4 Plate the asparagus, squeeze a bit of lemon on it, and carefully place the egg on top. Season with salt and pepper and serve hot.

NOTE The peak of asparagus season is April. When buying, look for straight, firm, bright spears and cook them as soon as possible. The best way to store them is either upright in a jar with the stems submerged in an inch of water, or with a damp paper towel around the ends in a large plastic or Ziploc bag.

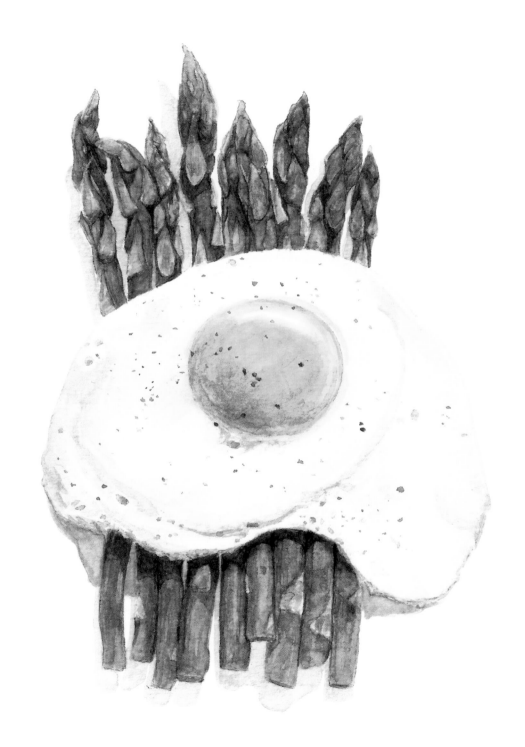

CHICKEN GYOZA

MAKES: 20

INGREDIENTS

For the Wrapper

1½ cups cake flour (200 grams)

1½ cups bread flour (200 grams)

½ tsp salt (2 grams)

1 cup warm water (240 ml)

extra flour for rolling dough

For the Filling

2–3 cups cooked chicken (250 to 375 grams)

½ white onion

2 scallions

½ tsp fresh ginger, peeled

2 garlic cloves

½ tsp sugar (2 grams)

½ tbsp sesame oil (7 ml)

1 tbsp cornstarch (12 grams)

½ tsp oyster sauce (2 ml)

2 tbsp soy sauce (30 ml)

pepper

sesame oil (for frying)

For the Dipping Sauce

1 tbsp rice vinegar (15 ml)

2 tbsp soy sauce (30 ml)

DIRECTIONS

1 To make the gyoza wrappers, sift the cake and bread flours into a bowl. Mix the salt in the warm water and slowly add to the flour. Knead the dough for 5 minutes and shape into small logs. Cover in plastic wrap and let it rest for 30 minutes at room temperature.

2 Finely chop the cooked chicken, onion, and scallions. Grate the ginger and mince the garlic. Combine the chicken, onion, scallions, ginger, garlic, sugar, sesame oil, cornstarch, oyster sauce, soy sauce, and a pinch of pepper in a large bowl. Mix well and refrigerate for 30 minutes.

3 Put a large piece of parchment paper over the counter for easy cleanup (or not, it's your counter). This will be where you roll out the wrappers. Line a baking sheet with parchment paper and place it on the counter (use this to hold the gyozas that you fold so you can bring them to the stove later). Sprinkle flour over both surfaces.

4 Take one of the dough logs and tear off small pieces to form balls the size of a quarter. Using a rolling pin or solid cup, roll out as thinly as possible and liberally sprinkle with flour to prevent the dough from sticking together. Repeat until all the dough is used.

5 Remove the gyoza mixture from the fridge and place a small bowl of water near the wrappers. Spoon a small amount of the gyoza mixture in a wrapper, dip your finger in the water, and run it along the edges of the wrapper, then

fold over and pinch to close. Sprinkle with some flour and place on the baking sheet. Repeat until all the dough and/or gyoza mixture is used.

6 You want to cook these in batches as soon as possible. In a large nonstick frying pan, add a few drops of sesame oil and place the gyoza in rows so that they are slightly touching. Add water to the pan so that the water reaches halfway up the gyoza, cover, and cook on medium-high heat to steam. When the water has evaporated, add a few more drops of sesame oil around the gyoza and fry until the bottom sides are golden and crisp. Remove and plate.

7 In a small bowl, combine the dipping sauce ingredients and enjoy.

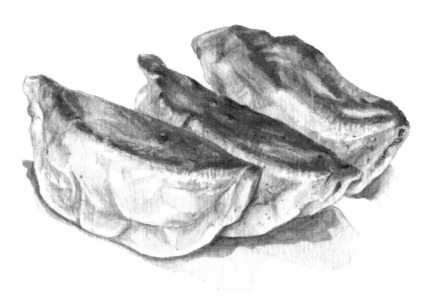

BRUSSELS SPROUTS WITH WALNUTS

SERVES: 4

DIRECTIONS

1 Chop the Brussels sprouts into halves or quarters.

2 Dice the red onion.

3 Heat olive oil in a large pan over medium-high heat.

4 Sauté the onion and Brussels sprouts for 15 minutes.

5 Add the walnuts and sauté for 5 more minutes.

6 Season with salt and pepper.

7 Serve with a good sprinkle of toasted sesame seeds.

INGREDIENTS

2 cups of Brussels sprouts (250 grams)

½ red onion

2 tbsp extra-virgin olive oil

½ cup walnuts (65 grams)

salt and pepper

1 tsp toasted sesame seeds (4 grams) (see pg 71)

NOTE Brussels sprouts have a wonderful nutty taste, especially when you add some walnuts or pine nuts to bring out this trait. To make a larger meal, add some cooked pasta or a grain, and a little more olive oil.

FRIED RICE

SERVES: 2

DIRECTIONS

1 Finely dice the carrot, onion, and scallions. Mince the garlic.

2 In a bowl, crack and beat eggs with a fork or whisk.

3 Heat a few drops of oil on a small nonstick pan over medium-high heat and pour the beaten eggs into the pan. Push the eggs around to create a well-cooked scramble, then remove them from the heat and place on a plate.

4 Heat olive oil in a wok or large pan over high heat and sauté the carrot, onion, scallions, garlic, and peas for 3 to 5 minutes or until the onions are translucent.

5 Add the leftover rice, sesame oil, soy sauce, and the oyster sauce (optional).

6 Turn the heat up to high. Fry the rice to desired crispiness and add the cooked egg.

7 Mix well, remove from the heat, and season with salt and pepper.

8 Serve with a few chopped scallions.

INGREDIENTS

1 carrot

½ red or white onion

1–2 scallions

2 garlic cloves, minced

2 eggs

2 tbsp extra-virgin olive oil (30 ml)

¼ cup peas (60 grams)

1 cup leftover white or brown rice (230 grams)

1 tbsp sesame oil (15 ml)

2–3 tbsp soy sauce (30–45 ml)

1 tbsp oyster sauce (optional) (15 ml)

salt and pepper

chopped scallions (optional garnish)

NOTE The key to this recipe is to use cold leftover cooked rice so the grains are firm and not sticky. Also, be sure to un-clump your rice before cooking. It is best to use a wok, but a large pan will also work. Just be sure to cook over high heat. This will give the rice that smoky, burnt flavor.

GREEN BEAN CASSEROLE

SERVES: 6

INGREDIENTS

1 lb fresh green beans (0.5 kg)

2 tsps salt (8 grams)

1 onion

8–10 white mushrooms

2 garlic cloves

2 tbsps butter (24 grams)

2 tbsps + ½ cup flour
 (140 grams)

1 cup chicken broth (240 ml)

1 cup half-and-half (240 ml)

½ tsp ground black pepper
 (2 grams)

1 cup milk (240 ml)

1–2 tbsps canola oil (5-10 ml)

DIRECTIONS

1 Wash the green beans and remove the stem ends.

2 Bring a large pot of water to a boil, then add 1 tsp salt and the beans. Blanch for 5 minutes. Drain and place in a large bowl of ice water.

3 Cut the onion in half. Finely dice half of the onion, and slice the other half into thin rings. Wash and slice the mushrooms and mince the garlic.

4 Preheat the oven to 450 °F (230 °C).

5 Melt the butter in a large pan over medium heat and sauté the diced onions and garlic until the onions are translucent.

6 Add the mushrooms and cook until the liquids have reduced.

7 Add 2 tbsps flour and stir continuously until well-incorporated.

8 Add the chicken broth, half-and-half, remaining salt, and pepper. Reduce the heat to low. Simmer for 10 to 12 minutes, stirring often, until the sauce has thickened. Then remove from the heat, stir in the green beans, and pour into a 1-quart casserole dish.

9 Fill a bowl with milk, add the ringed onions, and let them soak for 5 minutes.

10 Heat canola oil in a pan over high heat.

11 Fill a bowl with ½ cup flour, then dredge the milk-soaked onions in the flour and add to the hot pan. Fry in batches until golden and crispy, adding more oil as needed.

12 Top the creamy bean casserole with the fried onions and bake uncovered for 10 to 15 minutes.

NOTE To speed up the process, you can buy fried onions instead and just focus on the bean casserole part, or use breadcrumbs or old stale bread for the topping. I've even heard of people using potato chips to add a special crunch. You can also blanch the beans longer and not bake the casserole, if you want a crispier texture.

SMASHED POTATOES

SERVES: 4

DIRECTIONS

1 Wash the potatoes and place in a large pot.

2 Cover with water so they are fully submerged, add a pinch of sea salt, and bring to a boil. Boil the potatoes for 15 minutes.

3 Preheat the oven to 450 °F (230 °C).

4 Line a baking sheet with parchment paper.

5 Drain the potatoes carefully and place them on the baking sheet (they will be hot). Using a large mug or flat surface, smash each potato until flat (but still whole). Space the potatoes out so they are not touching.

6 In a bowl, combine the minced garlic, extra-virgin olive oil, and marjoram. Stir.

7 Using a pastry brush, coat each potato with the olive oil mixture. Season with salt and pepper and bake for 20 minutes.

8 Remove from the oven, flip each potato, coat the other side with the olive oil mixture, season with salt and pepper, and bake for another 15 minutes until crispy and golden.

9 Serve hot, or you can make ahead and then fry them up in a little olive oil right before serving as a side.

INGREDIENTS

12 baby potatoes

a pinch of sea salt

2 garlic cloves, minced

3 tbsp extra-virgin olive oil (45 ml)

1 tsp dried marjoram (or dried oregano) (4 grams)

salt and pepper

NOTE This is my favorite way to eat potatoes. It's like a mini baked potato with a crispy outer shell. It makes for an ideal side dish to just about anything! Just be sure to use a flat, sturdy object (like a thick mug) to smash your spuds. You need some *umph*, but don't want to completely break the potatoes apart, so smash slowly.

CREAMED SPINACH

SERVES: 4

DIRECTIONS

1 Finely dice the onion and mince the garlic.

2 In a large pan, melt the butter over medium heat.

3 Add the onions and garlic and season with a pinch of salt and pepper. Cook until the onions are translucent.

4 Add the flour and whisk continuously until well-combined.

5 Add the milk, heavy cream, lemon zest, and nutmeg. Simmer for 3 to 5 minutes over medium-low heat, until the sauce becomes thick.

6 Thoroughly wash the spinach and pat dry.

7 Add the spinach in batches and stir continuously so that nothing burns.

8 Cook for 3 to 5 minutes or until the spinach wilts.

9 Season with salt and pepper to taste and serve.

INGREDIENTS

½ white onion

2 garlic cloves, minced

3 tbsp butter

salt and pepper

¼ cup flour (32 grams)

1 cup milk (240 ml)

¼ cup heavy cream (60 ml)

⅛ tsp lemon zest (0.5 grams)

⅛ tsp nutmeg (0.5 grams)

1 large bag spinach
(142 grams)

NOTE Make sure you have a big bag of spinach because it will seriously decrease in volume. If the sauce becomes too watery (from the spinach), continue to cook over medium heat until it reaches the right consistency.

ROASTED ROOT VEGETABLES

SERVES: 4

DIRECTIONS

1 Preheat the oven to 425 °F (230 °C).

2 Chop the vegetables into roughly 1-inch pieces. Place them in a bowl.

3 Drizzle the vegetables with olive oil and sprinkle with oregano, salt, and pepper. Toss with your hands to coat everything evenly.

4 Place as a single layer on a large baking sheet lined with parchment paper. Make sure that nothing overlaps.

5 Roast for 45 minutes, tossing once. Cool for 5 to 10 minutes before serving.

INGREDIENTS

1–2 beets

2 carrots

1 parsnip

½ red onion

1–2 potatoes

1 tbsp olive oil (15 ml)

1 tsp dried oregano (4 grams)

salt and pepper

NOTE The veggies will shrink a little once roasted, so factor that into your serving-size equation. You can also try roasting with herbs like rosemary, thyme, and/or a dash of lemon juice. Or try adding a few sprinkles of balsamic vinegar for a rich, complex taste.

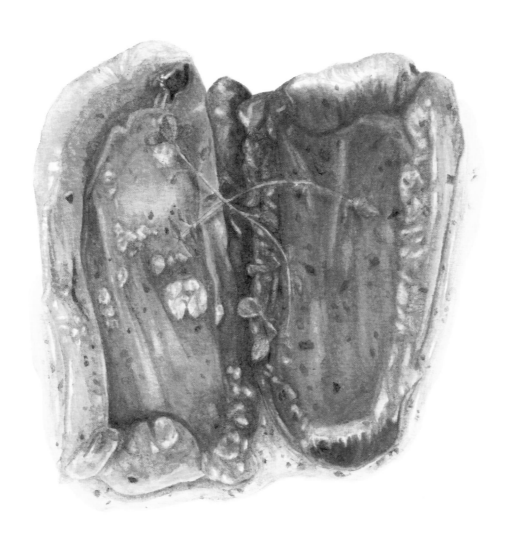

LUSIA'S PEPPERS

SERVES: 4

DIRECTIONS

1 Wash and core the peppers, removing all the seeds.

2 Slice the peppers into quarters.

3 Grill the peppers or heat 1 tsp olive oil in a large pan over medium-high heat and place the peppers skin side down. Cook for 5 to 8 minutes until the skin has blackened, then flip and cook the other side for another 5 to 8 minutes until that side has blackened too.

4 Let the peppers cool, then remove the blackened skin and place the peppers on a plate.

5 In a cup, combine the minced garlic, extra-virgin olive oil, lemon juice, honey, dried oregano, and black pepper. Whisk until well-combined.

6 Pour the mixture over the peppers so they are completely covered.

7 Cover with plastic wrap and refrigerate for at least 1 hour or up to 1 day to marinate.

8 Serve cold.

INGREDIENTS

2–3 large yellow peppers

4 tbsps + 1 tsp extra-virgin olive oil (65 grams)

3 garlic cloves, minced

1 tbsp lemon juice (15 ml)

1 tbsp honey (15 ml)

1½ tsps dried oregano (6 grams)

a pinch of black pepper

NOTE Orange and yellow peppers are best for this recipe because they are sweeter than the red or green kind. You can also grill the peppers by placing them over medium heat, skin-side down, and cooking until the skins are charred and easy to remove. Then peel and add the garlic mixture. This makes a great BBQ or burger side.

DINNER

WE'VE REACHED THE D-WORD. ALL THE EARLIER CHAPTERS HAVE LED UP TO THIS, SO LET'S talk about managing our expectations. Everybody has a different idea of what dinner is and should be. My perspective about this meal has changed dramatically, from being a total time-suck to an opportunity to create, nourish, and connect with myself and my family. This change in attitude has been the most fulfilling aspect of my entire cooking journey.

I had this notion that dinner was a magical time, when you'd gather around a perfectly curated table with family and friends and feel loved while eating some meat and vegetables. This meal would be calculated for maximum health and balance, based on the USDA Food Guide Pyramid, and then we'd all laugh and ask about each other's days.

I grew up on shows like *Family Matters* and *Full House*, and contrary to my own real experience, I still thought this was what I'd eventually get to do when I grew up. However, that food guide was totally messed up, and who is going to make all that food, set the table, and get everyone to sit down at the same time?

Real dinner isn't all white-toothed smiles and freshly steamed broccoli. Sometimes it's misshapen vegetables and a glass of wine by myself at 3 p.m., sometimes it's a cold-cut sandwich in my car or at my desk, and sometimes it's a really healthy juice and nothing else. Reality, meet empty fridge.

I still have that idea of the perfect dinner in my heart, but life has taught me that it doesn't have to be perfect. In fact, it can be simple and easy, which is more my style anyway. My real-life cooking experiences have always been defined by time constraints. It wasn't a choice: Make time to paint and therefore order out, or spend time in the kitchen (especially not in NYC, with the ease and convenience of free delivery and Seamless take-out).

I had felt that cooking was a waste of my valuable time. That all changed when I started asking troubling questions like: *Is learning how to feed myself really so terrible?* or *Why do I continue to want certain things and then do nothing to create those situations? Is working nonstop as meaningful and worthwhile as I am telling myself?*

These are all questions that you need to answer for yourself, but my conclusion was that if I ever wanted those magazine-worthy dinner scenes, I would need to take respon-

sibility and create them. First, learn how to cook some dinners. And once I made time for that, they weren't as time-consuming as I had expected.

Baked meals like roasted chicken will take a while to cook, but it's not like you're staring at the oven the entire time. You can do other things and let the oven do all the work. To make pasta from scratch takes half an hour, then an hour of waiting, and then it's ready to be cut and cooked. Making dinner is really not that big of a deal—it's figuring out what to cook and then gathering people together that is the hardest part.

Some other things I learned about making dinner: It tastes a hundred times better than anything you can buy at a restaurant (give or take a few exceptions) and is a fraction of the cost. There's no way you can get Korean bulgogi in the quantities we all want to eat it at a restaurant for less than it costs to make it at home, even if you buy the choicest beef. That pasta dish costs pennies to make and will only be as good as the restaurant chef, and not tailored to your personal preference.

Not that I don't love going out to eat, but if you're comparing quality to cost, cooking at home will always be the better choice. Aside from ramen (the alkaline water-based, fresh noodles in a full-bodied broth that has been cooking for 2 days) and other specialized foods that take a long time to cook or need to be made in large quantities, you can make most five-star dishes in the comfort of your own home. And for me, it's better to spend the extra money on nice table settings and linen.

Here are some of the dinners that I make on a regular basis and have happily cooked for small dinner parties or romantic meals in the garden.

WHAT AM I EATING?!

One big thing I eventually learned were the types of meat and where they are on an animal. This is super relevant, since the location of these cuts determines the texture, price, and ultimately how to cook them. For example, you're not going to use a NY strip for a beef stew. It doesn't make sense economically and won't taste as good in a stew as the cheap chuck cut. Here's the breakdown.

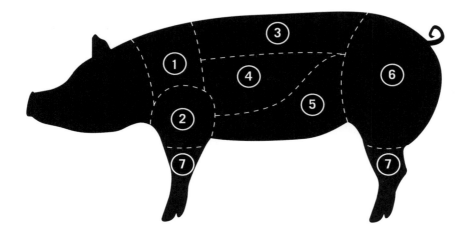

PORK CUTS

1—Blade Shoulder: a.k.a. "Boston butt" or "pork butt," even though this is from the front leg. Mostly used for pulled pork.

2—Arm Shoulder: a.k.a. "picnic ham," which is usually cured and smoked.

3—Loin: A cut along the top of the rib cage, made into pork chops or steaks, pork tenderloin, Canadian bacon, or baby back ribs.

4—Ribs: These are the spare ribs, St. Louis ribs, Kansas City-style ribs, and rib tips. They tend to be flatter and fattier than baby back ribs.

5—Belly: This cut is used for pork belly, bacon, side pork, and pancetta.

6—Leg: a.k.a. "ham." It also is used for pork leg, pork cutlets, strips, cubes, and roasts, and can be purchased with or without the bone.

7—Hocks & Trotters: A ham hock, a.k.a. "pork knuckle," is the shank portion of the pig leg. Mostly made of skin and tendons, it needs to be cooked for a long time. Trotters are the pig feet, used to make stocks and gravy.

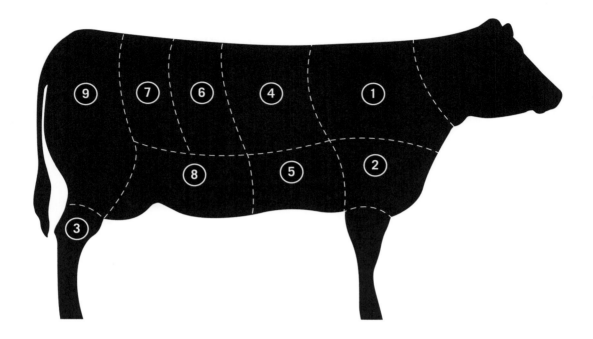

BEEF CUTS

1—Chuck: Chuck steak and chuck roast are the more economical cuts. Great for stewing, slow cooking, or braising. Also used as ground beef, chuck eye, cross-rib, top blade, and shoulder/arm roast.

2—Brisket: This is the breast or lower chest area and is a tough cut, with a lot of connective tissue because it carries much of the cow's body weight while the cow is standing. This cut takes preparation to use, and it is typically marinated and cooked slowly as corned beef, stew meat, or BBQ.

3—Shank: This includes the foreshank and the hind shank, and the meat tends to be tough and sinewy, making this cut cheap. It needs to be cooked for a long time in liquid. Great for a stew or making stock.

4—Rib: A primal cut of bone-in beef, sold as rib steak (a.k.a. rib-eye or cowboy cut) or short ribs.

5—Plate: Plate cut (or short plate) is from the belly of the cow, used for skirt steaks, hanger steaks, or pastrami. Typically cheap, tough, and fatty.

6—Short Loin: This includes the top loin and the tenderloin (including the coveted filet mignon, the most expensive of cuts) and is used to make porterhouse, strip steak (like NY Strip), and T-bone.

7—Sirloin: Steaks cut from the rear back to make top sirloin and bottom sirloin. This also includes some of the tenderloin.

8—Flank: A cut from the abdominal muscles. Typically long and flat. It can be grilled, fried, broiled, or braised, and it is best sliced against the grain.

9—Round: From the rear of the cow, this cut is lean and tough. It is divided into top round steak/roast, bottom round steak/roast, and rump.

MINIMUM COOKING TEMPERATURES OF MEAT

If unsure about whether meat is thoroughly cooked and safe to eat (excluding rare meats, which should be cooked using very fresh meat), take the temperature using a food thermometer. Be sure to measure from the center of the thickest part of the meat.

Fish: 145 °F

Steaks, Roasts, Chops: 145 °F

Pork: 145 °F

Ground Beef, Pork, Veal, Lamb: 160 °F

Ground Turkey, Chicken: 165 °F

Chicken/Poultry: 165 °F

How to Sear Meat: This technique is essential for making whatever meat you're cooking more flavorful. Think caramelized, deep brown, crispy yumminess. To do this properly, pat your meat dry beforehand using paper towels, and use a very small coating of oil (applied with a brush, spray, or paper towel). You should barely see it and it should be evenly spread over your pan. Then place your pan over VERY high heat!

Only when the oil starts to smoke should you add the meat. (You may also need to open some windows). And don't crowd the pan. Give the pieces of meat enough space so they don't overlap or touch. Lastly, be patient. Once you've added the meat, let it sit for a few minutes until it gets that golden brown color. It needs to stick to the pan to cook properly, but it will release when seared—then you can flip. Don't forget the sides of the meat, either.

LASAGNA

SERVES: 8

DIRECTIONS

1 If using store-bought lasagna noodles, cook in salted boiling water according to the package. If using Homemade Pasta (pg 162) or the no-boil store-bought noodles, skip this step.

2 Preheat the oven to 350 °F (180 °C).

3 To assemble the lasagna, layer the noodles, sauce, ricotta cheese, and mozzerella cheese, and repeat until all the ingredients are used up.

4 Bake uncovered for 30 to 45 minutes or until the cheese has melted. If you want the top browned, broil for 3 to 5 minutes.

5 Let the lasagna cool for 10 minutes. Serve with Parmesan cheese and fresh parsley.

INGREDIENTS

fresh or packaged lasagna noodles

3–4 cups tomato or Classic Bolognese sauce (pg 180) (720-960 ml)

2 cups mozzarella cheese (400 grams)

2 cups ricotta cheese (480 grams)

½ cup Parmesan cheese (100 grams)

fresh parsley

NOTE If you use the Homemade Pasta (pg 162) then you do not need to cook the dough beforehand. If you buy lasagna noodles, I suggest the no-boil option for the best outcome. I also suggest using fresh mozzarella cheese, the kind that comes in a large ball shape, rather than the shredded option.

SIMPLE ROASTED CHICKEN

SERVES: 4

INGREDIENTS

1 whole chicken

¼ cup sugar (55 grams)

½ cup salt (100 grams)

4 cups water (2 cups warm,
2 cups cold) (1 L)

2 tbsp olive oil (30 ml)

salt and pepper

a few sprigs of rosemary

DIRECTIONS

1 Wash the chicken inside and out, and remove any giblets. (Some whole chickens will include a small pouch in the cavity of the chicken that contains the liver, heart, and gizzard, which are called the giblets. Be sure to remove these before roasting.)

2 To make the brine: Combine sugar, salt, and 2 cups warm water. Mix well until the sugar and salt are dissolved. Add 2 cups of cold water and ice and make sure the solution is cool, then add the chicken. The chicken needs to be completely submerged. I like to place it in a large pot and flip the lid upside down with a weight on top. This way, the handle keeps the meat under the water. Let it soak for 4 to 5 hours on the counter.

3 Line a roasting pan with aluminum foil and place at the bottom of the oven to catch any drippings.

4 Preheat the oven to 350 °F (180 °C) and place a rack in the center.

5 Remove the chicken from the brine and pat dry with paper towels.

6 Rub all over with olive oil and season liberally with salt and pepper. Stuff the cavity with rosemary.

7 Once the oven is heated, place the chicken breast-side down, directly on the rack.

8 Bake for 2 hours or until the chicken is nicely browned and the internal temperature is 165 °F (74 °C). (It will

sizzle a lot and make the house smell like chicken and rosemary. This method is a bit messy, since the drippings get on the rack. Alternatively, you can purchase a vertical roaster, which will also get all the sides evenly crispy without as much of a mess.)

9 Carefully remove the chicken from the oven and let it cool for 10 minutes.

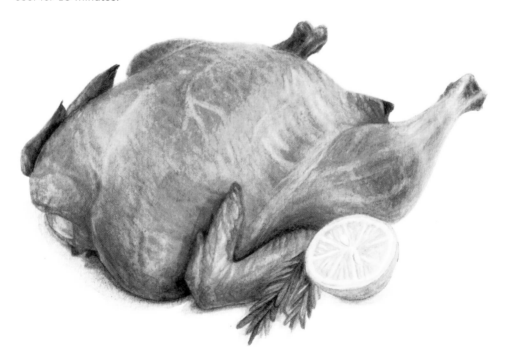

NOTE This is the most frequently cooked dish in my house, hands down! It's easy, cheap, and usually provides leftovers for Balsamic Chicken Salad (pg 58), soups (pgs 102–125), Chicken Gyoza (pg 136), Chicken Enchiladas (pg 166), etc.

A brine is a concentrated solution of salt and water, and it hydrates the meat, yielding a moist, tender chicken.

HOMEMADE PASTA

MAKES: LOTS OF PASTA

INGREDIENTS

1 cup white flour (128 grams)

1 cup semolina flour
 (128 grams)

⅛ tsp salt (0.5 grams)

3 eggs

olive oil

DIRECTIONS

1 Combine the white flour, semolina flour, and salt on a clean, flat surface and mix with your hands, then make a small well (hole) in the center of the flour mixture.

2 Crack the eggs into the well and, using a fork, whisk the flour and eggs until they become chunky.

3 Knead the dough until well-combined. This should take about 15 minutes. (You should be sweating a bit—that dough is tough, but it will soften later.)

4 Roll the dough into a ball and rub a little olive oil over the surface. Cover in plastic wrap and let it rest at room temperature for 1 hour.

5 Lightly dust the counter with flour and divide the dough into quarters. Roll out each piece into long, thin strips. Try to get it as thin as possible. (You may need to use a few light dustings of semolina flour to prevent sticking.)

6 Cut into any pasta shape that you want, or store in an airtight container for up to 1 week. If making long noodles, cut the dough into a long rectangle, and roll it up, creating a cylinder. Then cut into strips, which will unravel into long strands.

7 To cook, bring a large pot of salted water to a boil and add a few drops of olive oil. Gently drop in the pasta and cook to desired texture. (The pasta should cook more quickly than the dried, store-bought kind. To test, remove one noodle and taste.)

8 Drain the pasta and top with your favorite sauce.

NOTE The key to this recipe is to use the "well method" (Step 2). You make a mound of flour, then hollow out a hole in the center, creating a crevice large enough to hold the eggs. Then, using a fork, gently mix, using small circular motions around the edges of the eggs until they are too thick to mix with a fork. Then start kneading.

GRANDMA JULIA'S ARTICHOKES

SERVES: 2

INGREDIENTS

2–4 artichokes

2 cups breadcrumbs
(400 grams)

½ tsp oregano (2 grams)

½ tbsp Parmesan cheese
(7 grams)

2 garlic cloves, minced

salt and pepper

1 tbsp olive oil (15 ml)

DIRECTIONS

1 Cut the tips of each outer artichoke leaf with scissors. Using a knife, chop the top ½ inch off the artichoke, and shorten the stem so there is only an inch from the base of the artichoke to the bottom of the stem.

2 Thoroughly wash the artichokes. This is very important! Gently open each leaf (make sure they stay attached) and rinse inside, particularly in the center "choke" area.

3 In a bowl, combine the breadcrumbs, oregano, Parmesan cheese, minced garlic, a few shakes of salt and pepper, and olive oil. Stir. Stuff the mixture in between each artichoke leaf and in the center. It's okay if some of the stuffing falls out but try to pack it in as much as you can.

4 You need a deep pot with a lid, in order to make sure that the artichokes will be completely covered. Place the artichokes upright and as straight as possible, so the stuffing doesn't fall out. Add some water to the pot until it reaches the base of the leafy part of the artichokes, and bring it to a boil. Then reduce to a simmer and cover with a lid.

5 Cook for 1 hour. (Be sure to check every 15 to 20 minutes to make sure there is enough water in the pot. If not, add more water, or your pot will burn.)

6 Test if the artichokes are done by carefully removing one of the leaves from the middle of the artichoke. If it pulls out easily and the fleshy part is soft, then it's ready. Remove with a large slotted spoon or tongs and let the artichokes cool for 5 to 10 minutes, then serve.

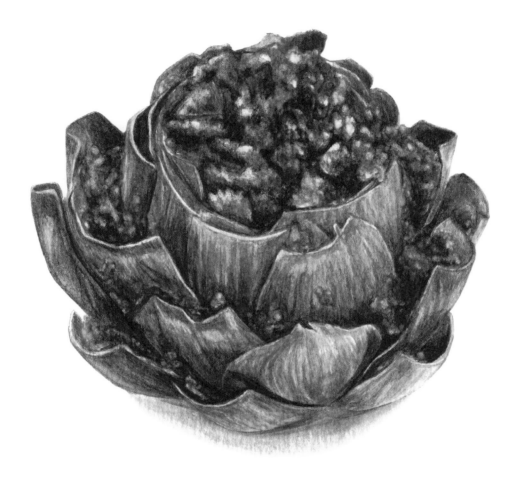

NOTE My grandma was a really amazing woman and cook. I loved it when she'd make this recipe and always thought it was so much fun to eat. There are some important things to know if you've never cooked or eaten an artichoke. When selecting, choose artichokes that are compact (if the leaves are open it won't be as tasty). To consume, you pull the outer leaves off the plant and scrape the meaty parts off with your teeth. Eventually, you will get to the center, called the "choke," which you do NOT eat! It is yellow, prickly, and hairy-looking—spoon that part out. Underneath will be the "heart," and you eat the entire thing, stem included. This dish also reheats well. You can store it in an airtight container in the refrigerator for up to 2 days.

CHICKEN ENCHILADAS

SERVES: 4

INGREDIENTS

1 white onion

2–3 bell peppers

2–3 cups cooked chicken
(250-375 grams)

1 tbsp olive oil (15 ml)

3 garlic cloves, minced

3 tsp chili powder (36 grams)

2 tsp ground cumin (8 grams)

2 tsp sugar (8 grams)

1 can (28 oz) tomato sauce
(0.8 L)

1 cup water

salt and pepper

2 cups shredded cheddar
cheese (250 grams)

½ cup fresh cilantro

6–8 flour tortillas

DIRECTIONS

1 Chop the onion and bell peppers. Shred the cooked chicken.

2 Heat olive oil in a large saucepan over medium-low heat and sauté the onions and peppers for 3 to 5 minutes.

3 Stir in minced garlic, chili powder, ground cumin, and sugar.

4 Add the tomato sauce and water and bring to a simmer.

5 Preheat the oven to 400 °F (200 °C).

6 Add the chicken, reduce the heat to low, cover, and cook for 8 to 10 minutes, until the sauce thickens.

7 Using a strainer with a bowl underneath, strain the mixture to create the enchilada sauce. Taste and season with salt and pepper.

8 Place the strained chicken in a separate bowl and add 3 to 4 tbsp of the enchilada sauce, 1 cup of shredded cheddar cheese, and chopped cilantro. Stir.

9 Warm the tortillas in the microwave or in a large pan over low heat to make them flexible.

10 Spoon the chicken mixture into the tortillas, roll them up, and place them in a tight row in a baking dish.

11 Pour the enchilada sauce on top and sprinkle with 1 cup of shredded cheese.

12 Cover with aluminum foil and bake for 20 minutes, then remove the aluminum foil and bake until the cheese is nicely melted.

13 Serve with cooked rice and beans.

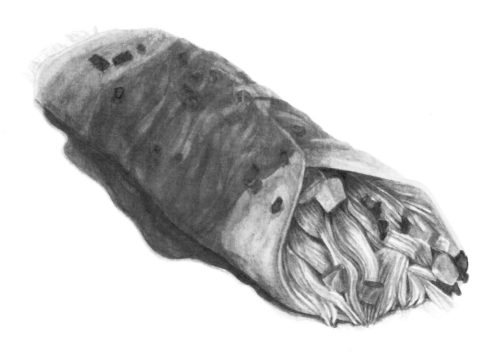

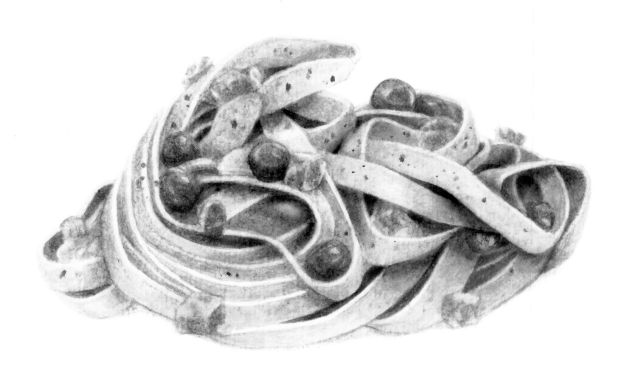

SIMPLE CARBONARA

SERVES: 2

DIRECTIONS

1 Bring a large pot of salted water to a boil and cook the linguine. Add 1 tsp olive oil to the water to prevent the strands from sticking.

2 In a large pan, sauté the pancetta over medium-high heat until crispy.

3 Add the peas, stir, and cook for 3 to 5 minutes.

4 In a large bowl, crack the eggs, add the Pecorino Romano, and whisk together.

5 Once the pasta is cooked, reserve ⅛ cup of the pasta water and then strain the pasta.

6 Quickly add the pasta to the egg mixture and stir so the eggs thicken into a sauce. If you want the sauce to be more liquid, add the reserved pasta water and continue stirring.

7 Add the pancetta and peas, stir, and season with coarse pepper. Serve immediately.

INGREDIENTS

a large handful of dried linguine

a pinch of salt

1 tsp olive oil (5 ml)

1 cup pancetta (250 grams)

⅓ cup fresh peas (70 grams)

2 eggs

1 tbsp grated Pecorino Romano cheese (12 grams)

coarse pepper

NOTE For such a simple recipe, it took me a few tries to get this right. Timing is key to this dish. You need to add the pasta while it's still hot enough to heat the egg, otherwise it will be a soupy mess. However, you don't want the pasta to be too hot or it will cook the egg and be chunky. Practice makes perfect.

SANAË'S GALETTE

SERVES: 4

INGREDIENTS

2 cups light buckwheat flour
(250 grams)

2 cups water (500 ml)

1½ tsp coarse sea salt
(7.5 grams)

1 egg yolk

1 tbsp olive oil (15 ml)

4 fresh eggs

salted butter

4 tbsp grated Gruyère cheese

4 slices ham

DIRECTIONS

1 In a large bowl, combine the buckwheat flour and coarse sea salt. Slowly add the water and beat with a wooden spoon. The batter will be elastic and heavy. You'll need some good muscles and patience as you beat the batter for 10 minutes. The longer you beat, the lighter the batter will become. Then cover with plastic wrap and let it sit in the refrigerator for 4 to 5 hours or overnight.

2 Separate one egg. Put the egg white aside for a different use. In a small bowl, combine the yolk with the olive oil and whisk. (Or you can just use olive oil.)

3 Heat a large pan until it's uniformly very hot. Test by flicking water onto the pan—it should sizzle and evaporate. Grease the pan by dipping a rolled-up paper towel into the oil/egg mixture and carefully rub it across the pan, or just use oil.

4 Ladle the batter onto the surface and roll the pan to spread the mixture as thinly as possible, or use a râteau if you have one. Once the edges curl up and the bottom is browned, carefully run your spatula underneath and flip.

5 Slather with butter, then add an egg (you can break apart the white a little or spread it so it cooks more quickly), then the cheese, then the ham. Repeat 4 times. It's nice to sprinkle the cheese to the sides so it gets that lovely crispness!

6 Fold like an envelope, leaving the middle open (see painting). Eat while hot!

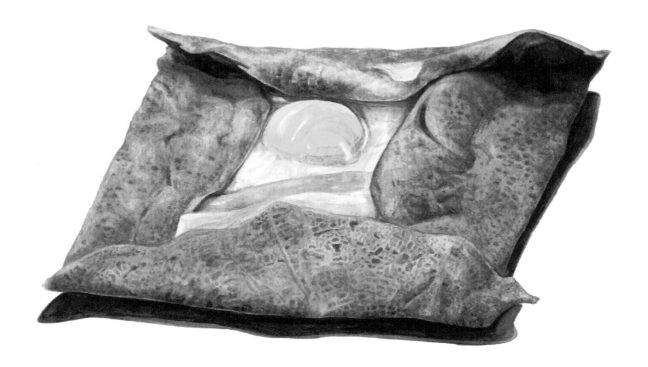

NOTE This amazing recipe is from a good friend, Sanaë Lemoine, and has been passed down from generation to generation in her family. Galettes are similar to crêpes, but use buckwheat instead of white flour. You can fill them with just about anything, but I prefer the Lemoine way, with a fresh slice of ham and a lightly cooked egg.

RATATOUILLE

SERVES: 4

DIRECTIONS

1 Finely dice the onion, peppers, zucchini, and tomatoes.

2 In a large pot, heat a few teaspoons of olive oil and cook the onions over medium-low heat, until translucent.

3 Add the peppers, stir, and cook for 3 minutes.

4 Add the zucchini, minced garlic, bay leaf, and thyme. Season with salt and pepper. Stir and cook for 5 minutes.

5 Add the chopped tomatoes and dry white wine. Lower the heat, cover, and cook for 30 minutes, stirring occasionally.

6 Season with salt and pepper to taste and serve traditionally with a sunny-side up egg and fresh baguette (optional).

INGREDIENTS

1 yellow onion

1 red pepper

1 yellow pepper

1 zucchini

2 heirloom tomatoes

a few tsp olive oil

3 garlic cloves, minced

1 bay leaf

5 sprigs fresh thyme

salt and pepper

¼ cup dry white wine (60 ml)

4 eggs

NOTE When I make this I tend to make a lot so I will have leftovers for breakfast, lunch, and dinner, like so:
Breakfast: With hash browns or fried potatoes and a poached egg.
Lunch: Over a bed of spinach with a slice of toast or fresh baguette.
Dinner: Over pasta with Parmesan cheese and a glass of wine.

THE PERFECT STEAK

SERVES: 2

INGREDIENTS

½ lb grass-fed Angus steak, NY strip (225 grams)

½ tsp ground black pepper (2 grams)

½ tsp dried thyme (2 grams)

½ tsp garlic powder (2 grams)

½ tsp chili powder (2 grams)

¼ tsp sea salt (1 grams)

1 sprig fresh rosemary

2 garlic cloves

2 tbsps extra-virgin olive oil (30 ml)

5 tbsp butter (70 grams)

DIRECTIONS

1 Using a very sharp knife, trim off the the fat and gristle.

2 Combine the ground pepper, dried thyme, garlic powder, chili powder, and sea salt. Mix until well-combined.

3 Rub the steak with the spice mixture and rosemary.

4 Cut the garlic cloves in quarters and set aside.

5 Heat olive oil in a large nonstick pan over high heat. Wait until it is very hot and smoking.

6 Using kitchen tongs, carefully place the steak on the pan. (Be careful, it will splatter, so put the steak down and away from you.)

7 Sear the steak for 1 to 2 minutes on all sides. (Make sure the meat is browned, but not burned. A good guideline for cooking a steak is that you want the surface of the steak to be firm, with the middle tender and flexible).

8 Lower the heat to medium and add the garlic cloves to the pan.

9 Add 3 tbsp of butter. Carefully tilt the pan sideways and spoon the butter mixture onto the steak. This is called basting, and you want to do it for 1 minute, then flip and baste the other side for 1 minute.

10 Turn off the heat, and place the steak on a cutting board. Let it rest for 3 to 5 minutes (depending on the thickness of the steak).

11 Slice the steak to stop it from cooking and serve immediately.

NOTE Steaks need time to rest on a cool surface, which will allow the juices to absorb into the meat instead of spilling out, as they would if the meat were cut immediately. These juices make a steak taste better, so patience = flavor.

ROSEMARY'S EGGPLANT PARMESAN

SERVES: 6–8

INGREDIENTS

1 can (28 oz) whole peeled
 tomatoes (0.8 L)

1 tsp extra-virgin olive oil (5 ml)

salt and pepper

2 eggplants

2–3 eggs

3 cups breadcrumbs
 (600 grams)

canola oil

2–3 cups shredded mozzarella
 cheese
 (400–600 grams)

fresh basil

DIRECTIONS

1 In a blender, purée the whole peeled tomatoes with olive oil and a pinch of salt and pepper.

2 Wash and slice the eggplants into ⅛- to ¼-inch thick pieces.

3 In a bowl, whisk eggs (depending on how large the eggplants are).

4 Pour the breadcrumbs onto a plate. (Keep handy because you may need more.)

5 Heat a large nonstick pan over medium-high heat and add canola oil.

6 Wait until the pan is hot, then dip an eggplant slice into the egg and then the bread crumbs so the entire slice is coated. Place in the pan. Repeat until you fill the pan with eggplant slices and fry both sides. Remove the eggplant to a plate and pat down with paper towels. Repeat in batches until all the eggplant is cooked.

7 Preheat the oven to 350 °F (180 °C).

8 In a 2-quart baking dish, layer tomato sauce, eggplant, and mozzarella cheese. Continue layering until all the eggplant is used and bake for 25 to 30 minutes or until the cheese is melted.

9 Serve with fresh basil and any extra tomato sauce.

NOTE This recipe is my mom Rosemary's dish, and something I look forward to eating whenever I go home. It's a labor of love since it takes a while to fry all the eggplant, but afterwards you'll have a lot of leftovers to use throughout the week. It goes well over pasta or as a cold or hot sandwich. Store in an airtight container for up to 5 days.

PORK CUTLETS & MASHED POTATOES

SERVES: 2–3

INGREDIENTS

3–4 potatoes

2 tbsp butter (28 grams)

¼ cup heavy cream (60 ml)

salt and pepper

3–4 pork tenderloins

1 cup flour (128 grams)

2 eggs

2 cups breadcrumbs
(400 grams)

canola oil

pickles (optional)

DIRECTIONS

1 Peel and chop the potatoes into cubes.

2 Place the potatoes in a pot of boiling water, reduce to a simmer, and cook until tender.

3 Drain the water and, using a masher or fork, mash the potatoes. They should give easily. Add the butter and the heavy cream and whip with a fork until fluffy. Season with salt to taste. (The salt makes it delicious, but the dish can become too salty very easily, so add little by little.)

4 Cut the fat from the pork and place the tenderloins in between two sheets of plastic wrap. Using a meat tenderizer, pound until the chops are about ¼ inch thick.

5 Season each side with a good pinch of salt and pepper and rub into the meat.

6 Coat each side of the meat with flour and shake off the excess.

7 Set up a workstation, because the frying happens fast. Whisk the eggs in a bowl, pour some breadcrumbs on a plate, and set up two large pans, one with a lid. Coat 1 pan with 2 tsp canola oil over medium-high heat. Place the other pan over low heat and cover (this will be used to keep the cutlets warm).

8 Once that is all ready to go, dip one of the pork chops in the egg until covered, then dip in the breadcrumbs, and place on the hot pan. Fry each side for about 3 to 5 minutes or until a golden crust forms, then place in the second pan to keep warm. You will need to fry in batches, so repeat these steps for all the cutlets.

9 Depending on how many cutlets you have, you may need to add more oil and clean the pan in between cooking, using a paper towel (be careful not to burn yourself).

10 Serve the pork cutlets and mashed potatoes with pickles for the traditional Polish experience.

CLASSIC BOLOGNESE

SERVES: 4–6

INGREDIENTS

2 carrots

3 celery stalks

1 onion

2 tbsp butter

2 tbsp olive oil (30 ml)

¼ lb ground pork (120 grams)

¼ lb ground veal (120 grams)

¼ lb ground beef (120 grams)

salt and pepper

1 can (6 oz) tomato paste
 (170 grams)

1 cup milk (240 ml)

1½ cup dry white wine
 (optional) (360 ml)

dried spaghetti

fresh basil

freshly grated Parmesan cheese

DIRECTIONS

1 Mince the carrot, celery, and onion.

2 Heat the butter and olive oil over medium-low heat. Add the vegetables and stir frequently. Cook for 20 minutes. (Make sure this does not burn!)

3 Add the ground pork, veal, and beef, and season with a pinch of salt and pepper. Break apart the chunks using your spoon or spatula and cook over low heat for 40 minutes. Then raise the heat to medium and cook for 10 more minutes to slightly brown the meat. (This last part is optional: I like a more browned taste to my meat.)

4 Taste and season with salt and pepper. Add the tomato paste, stir until well-combined, and cook for 20 minutes over low heat.

5 Add the milk and cook for 5 to 8 minutes, until the milk has evaporated, and season again to taste. (At this point, you can stop here and eat it as is, so make sure it's well-seasoned and delicious. But if you want a thinner sauce, continue on.)

6 Add the white wine and cook until the alcohol has evaporated, about 45 minutes to 1 hour. Taste again and season with salt and pepper.

7 Cook the pasta in boiling water according to the package. (Or follow the Homemade Pasta recipe on pg 162.)

8 Add the pasta to the sauce and stir until everything is coated.

9 Serve with fresh basil and Parmesan cheese.

NOTE The key to this recipe is the carrot, celery, and onion combination, known as a "mirepoix" (pronounced meer-pwah). This trio of veggies is used to add flavor and aroma to stocks and sauces. It should be cooked over very low heat, and if it burns then you might as well start all over again.

SCALLOPS, CORN, & TARRAGON

SERVES: 2

DIRECTIONS

1 Cut the corn off the cob and mince the shallot and garlic. Finely chop the tarragon leaves.

2 Season both sides of the sea scallops with salt and pepper.

3 Heat 1 tbsp olive oil in a large pan over medium heat. Add the corn and lightly sauté.

4 Add the shallot and garlic and stir. Sauté for 2 to 3 minutes.

5 Add the dry white wine, heavy cream, and tarragon. Season with salt and pepper. Reduce the heat to medium low and simmer until the sauce thickens, about 5 minutes.

6 Lightly oil a pan over medium-high heat and cook the scallops on each side for 2 to 3 minutes or until caramelized and opaque.

7 Spoon the corn mixture on the plate and place the scallops on top. Season with salt and pepper and serve immediately.

INGREDIENTS

1 corn on the cob

1 shallot

2 garlic cloves

a handful of fresh tarragon

8 large sea scallops

salt and pepper

1 tbsp + 1 tsp extra-virgin olive oil (35 ml)

¼ cup dry white wine (60 ml)

¼ cup heavy cream (60 ml)

NOTE Tarragon tastes great with seafood. It is essential that you use fresh tarragon, which has a light anise or licorice flavor, reminiscent of fennel. The creamy, crunchy corn mixture, paired with the delicate texture of the scallops, makes this a transcendent dish for such a simple and quick recipe.

KOREAN BULGOGI

SERVES: 2

INGREDIENTS

½ white onion

4 oz thinly sliced beef (sirloin, eye round or rib eye)

2 garlic cloves

¼ inch piece ginger, peeled

2 tbsp soy sauce (30 ml)

2 tsp mirin (10 ml)

1 tbsp sugar (15 grams)

4 tsp sesame oil (20 ml)

1 tsp raw sesame seeds (4 grams)

coarsely ground pepper

½ zucchini

1 carrot

¼ tsp salt (1 gram)

3–4 shiitake mushrooms

1 tsp extra-virgin olive oil (5 ml)

toasted sesame seeds (see pg 71)

large butter lettuce leaves

cooked rice (optional)

DIRECTIONS

1 Thinly slice the onion, and beef into thin strips. Mince the garlic and ginger.

2 Combine the soy sauce, mirin, sugar, 2 teaspoons sesame oil, raw sesame seeds, minced garlic, minced ginger, and a pinch of coarsely ground pepper in a bowl. Add the onions and beef and marinate for 1 hour in the refrigerator.

3 Cut the zucchini and carrot lengthwise into thin strips and season with salt. Place in a bowl and leave for 10 to 15 minutes to remove the water.

4 Wash and slice the mushrooms.

5 Rinse the salt from the zucchini and carrot and squeeze out the water. In a large pan, cook the vegetables in 2 teaspoons sesame oil over medium-high heat for about 3 to 5 minutes, then place on a plate to cool.

6 Traditional bulgogi is grilled. However, if this is not an option, you can pan fry. In the same pan used to cook the vegetables, heat the olive oil over high heat. Once the pan is hot, add the beef strips and sear each side, then remove to the vegetable plate. (Use tongs so that you keep the marinade in the bowl. You may need to do this in batches.)

7 Reduce the heat to medium and add the mushrooms, sautéing until the water has evaporated. Then add the zucchini, carrots, and the marinade juices and cook for 3 to 5 minutes.

8 Add the meat back to the pan. Season with coarsely ground pepper and stir. Cook for 1 minute.

9 Season with toasted sesame seeds and serve wrapped in a large butter lettuce leaf with a side of rice.

NOTE The hardest part of this recipe will probably be finding the meat. Bulgogi meat is either rib eye, sirloin, or a tender cut, sliced very thin (⅛ to ¼ inch). It is sold pre-cut in Asian markets, but you can use thin flank or skirt steaks, or just ask your butcher to slice the meat for you. Buy meat with some marbling (the intramuscular fat in the beef that looks like marble) and don't overcook it.

SWEDISH MEATBALLS

SERVES: 6

INGREDIENTS

1 piece of white bread

½ cup milk (120 ml)

½ lb ground beef (225 grams)

¼ lb ground pork (113 grams)

a bunch of fresh parsley

1 tbsp dried dill (12 grams)

1 egg

2 tsp extra-virgin olive oil

5–6 mushrooms

2 tbsp butter (28 grams)

2 tbsp flour (16 grams)

2 cups beef stock (480 ml)

¼–½ cup sour cream
 (60-120 ml)

salt and pepper

DIRECTIONS

1 Soak the bread in a bowl of milk. (You may need to cut it up to get it all submerged.)

2 In a large bowl, combine the ground beef and ground pork and mix well.

3 Finely chop some parsley. Squeeze the milk out of the bread. Add the parsley, dill, and bread to the ground meat mixture.

4 Crack an egg into the bowl with the ground meat and mix well. Then refrigerate for 1 hour to stiffen.

5 Roll the meat into balls. (The smaller they are, the faster they will cook.)

6 Heat a large pan with olive oil over high heat. Once hot, add the meatballs and toss frequently until all the sides are browned and the meat is cooked through. Then remove to a plate to cool.

7 Wash and slice the mushrooms. In the same pan, cook the mushrooms over high heat until all the water has evaporated.

8 Add the butter and, once melted, whisk in the flour to make a roux.

9 Add the beef stock, stir, and cook for 5 minutes.

10 Add the sour cream and stir, then add the meatballs back to the pan. Taste and season with salt and pepper if needed. (If too thick, add more stock. If too thin, add 1 tsp flour or sour cream.)

11 Serve with fresh parsley.

NOTE The key to making tender, springy meatballs is to use a "panade" a.k.a "panada." This is made from bread soaked in milk, and it is combined with ground meats to add moisture and bind the ingredients together. Also, make sure the meatballs are fully cooked inside by slicing one open to see if it's cooked through.

SPAGHETTI ALLE VONGOLE

SERVES: 2

INGREDIENTS

2 lbs small clams (1 kg)

2 garlic cloves

1 shallot

a handful of fresh parsley

a handful of dried spaghetti

3 tbsp extra-virgin olive oil
 (45 ml)

1 tbsp butter (14 grams)

⅛ tsp red pepper flakes
 (0.5 grams)

¼ cup dry white wine (60 ml)

salt and pepper

DIRECTIONS

1 When you're ready to cook the clams, remove them from the refrigerator and check each clam carefully to make sure they are alive. Only cook live clams! (The clams should be closed tightly. If they are open, tap the shell or try squeezing closed gently to see if the clam will close by itself. If it doesn't close after doing these things, discard it.)

2 Scrub and rinse the clams, then soak them for 30 minutes in cold water to filter out any salt or sand. Drain and rinse thoroughly again. You can repeat this one more time to make sure the clams are cleaned of sand and grit.

3 Mince the garlic and shallot. Chop the parsley.

4 Bring a pot of water to a boil and cook the pasta for 2 minutes less than the recommended time on the package, or so it is almost al dente (cooked but firm). Drain and drizzle a little olive oil on the pasta, then toss to prevent sticking.

5 Simultaneously, heat olive oil and butter over high heat in a large pan. Sauté the shallot for 1 to 2 minutes. Add a pinch of red pepper flakes, the clams, wine, and garlic. Stir, cover, and cook for 5 to 8 minutes.

6 Once the clams open, use tongs and place them on a plate.

7 Add the pasta and parsley to the clam liquids and cook for 2 minutes or until the liquids have evaporated and been absorbed. Add the clams back to the pan and stir. Drizzle a little bit of olive oil (optional) and season with salt, pepper, and fresh parsley.

8 Serve immediately.

NOTE Right after bringing the live clams home, make sure to place them in a bowl in the refrigerator, uncovered, so they can breathe. You want to cook them within a day of purchasing. As I mentioned in the recipe, it's very important to only eat live clams. Remove any clams that have cracked shells or are open before cooking them. And once they are cooked, if there are clams that do not open, discard these also.

ROASTED LAMB CHOPS

SERVES: 2

DIRECTIONS

1 Remove the rosemary leaves from the stems and chop them finely. Mince the garlic.

2 In a shallow bowl or flat container, combine the chopped rosemary, garlic, dried oregano, olive oil, balsamic vinegar, the juice of 1 lemon, and a pinch of salt and pepper. Whisk together, then add the lamb chops and rub the marinade into the meat. Make sure the lamb is well-coated, then cover and refrigerate overnight.

3 Remove the meat from the refrigerator and let it warm to room temperature before cooking.

4 Preheat the oven to 400 °F (200 °C).

5 Heat the butter and olive oil in a large pan over high heat. Once hot, sear each side of the meat and baste by spooning the butter-oil mixture on top of the lamb until nicely browned.

6 Place the chops in a baking dish, then coat with the liquids from the pan and a few sprigs of fresh thyme. Bake for 15 to 35 minutes (depending on the thickness of the meat and how rare you want it). Be sure to test using a thermometer to determine when the chops are done, then let them cool for 5 minutes before serving.

INGREDIENTS

4 sprigs fresh rosemary

3 garlic cloves

1 tsp dried oregano (4 grams)

½ cup olive oil (120 ml)

1 tbsp balsamic vinegar (15 ml)

1 lemon

salt and pepper

4 1-inch thick lamb chops

2 tbsp butter (24 grams)

1 tbsp olive oil (15 ml)

4 sprigs fresh thyme

NOTE This recipe sears the lamb, creating a nice crust, and finishes the cooking process in the oven. Make sure the meat is at room temperature before cooking, otherwise you'll need to cook it much longer. The internal temperatures should be: medium-rare = 145 °F (63 °C), medium = 160 °F (72 °C), well-done = 170 °F (77 °C).

CHICKEN MARSALA

SERVES: 2

DIRECTIONS

1 If you have a thick cut of chicken breast, you may want to cut it in half horizontally and pound it down, to create thinner and therefore quicker-cooking meat. Season both sides of each chicken breast with some salt and pepper.

2 In a bowl, combine the flour, minced garlic, salt, pepper, and dried oregano.

3 Wash and slice the mushrooms thinly and chop the parsley.

4 Heat olive oil in a large pan over high heat.

5 Once the pan is very hot, dredge the chicken in the flour mixture and add to the pan.

6 Sear the first side (about 5 minutes) then add the butter and mushrooms. (Do not crowd the mushrooms. Make sure they don't overlap or stick together.)

7 Sear the second side of the meat, stir the mushrooms, and add the marsala wine.

8 Reduce the heat to medium-low and simmer until the internal temperature of the chicken is at least 165 °F (74 °C). (If the marsala evaporates before then, just add a little more and continue to simmer until cooked.)

INGREDIENTS

2 boneless free-range chicken breasts

salt and pepper

¼ cup flour (32 grams)

2 garlic cloves, minced

¼ tsp salt (1 gram)

¼ tsp black pepper (1 gram)

¼ tsp dried oregano (1 gram)

3–4 white or cremini mushrooms

a few sprigs fresh parsley

2 tbsp extra-virgin olive oil (30 ml)

2 tbsp butter (28 grams)

½ cup dry marsala wine (120 ml)

NOTE Marsala is a wine made in Sicily, and comes in a sweet or dry style. Dry marsala wine is used for cooking savory dishes and adds a nutty, caramelized flavor. If you don't have this handy, you can substitute it with dry white wine and 1 tsp of brandy.

BASIC STIR-FRY

SERVES: 2

INGREDIENTS

14 oz extra-firm tofu or meat (400 grams)

a handful of snow peas

1–2 peppers

1 tbsp peanut or vegetable oil (15ml)

¼ cup cornstarch (32 grams)

FOR THE SAUCE

2 garlic cloves

1–2 tsp ginger (6 grams)

1 tbsp soy sauce (20 ml)

1 tbsp honey (20 ml)

¼ cup water (60 ml)

DIRECTIONS

1 Remove the tofu from the package and squeeze as much water out as possible. Place between two paper towels and add a heavy weight or object on top to squeeze the water out. Let it sit for 5 to 10 minutes. (You can use meat or shrimp instead; just make sure the meat is cut into small, similar-size pieces.)

2 Cut the peppers into small, similar-size pieces and mince the garlic and ginger for the sauce.

3 Combine the sauce ingredients and mix well. Have everything you will need to cook with within arm's reach because the frying happens fast.

4 Heat a wok or large pan over high heat. Once hot, add the oil and swirl so the pan is evenly coated.

5 Fill a shallow bowl with cornstarch and coat the tofu, meat, or shrimp in the cornstarch. Add to the pan and cook for 5 to 8 minutes, tossing once or twice so all the sides cook evenly and nothing burns, then remove to a plate.

6 Add the vegetables, and cook for 3 to 5 minutes.

7 Once the vegetables have softened, add the tofu or meat back to the pan, and pour the sauce over everything.

8 Toss so everything is coated in the sauce and cook for 1 to 2 minutes.

9 Serve over your grain of choice.

NOTE A stir-fry happens quickly, so it's good to make sure all the ingredients are chopped, mixed, and ready to go. When you cut up the meat and vegetables, make sure they are equal in size so they cook evenly. It is best to use a wok, but a large pan will work too. Just make sure the pan is hot and cook the vegetables and/or meat in batches, so nothing burns.

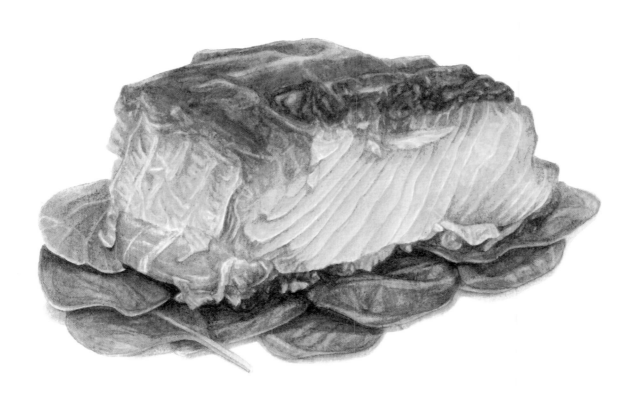

HONEY MUSTARD SALMON

SERVES: 2

DIRECTIONS

1 Preheat the oven to 450 °F (230 °C).

2 In a small saucepan, combine the brown sugar, honey, butter, ginger, and mustard. Heat over medium low and stir until everything is melted and well-combined. Then remove from the heat.

3 Cut the salmon into 2 to 3 inch fillets (if not separated already) and brush one third of the honey mustard mixture over the salmon.

4 Heat the olive oil in a large pan over high heat. Once it is very hot, place both fillets skin-side down and fry for 6 to 7 minutes, then turn over and fry the other side for 2 to 3 minutes or until golden. (Don't worry if the skin burns.)

5 Place the fillets in a baking dish, skin-side down, and brush another third of the honey mustard glaze on the fillets.

6 Bake for 5 minutes.

7 Remove the skin, brush on more of the glaze, and serve immediately.

INGREDIENTS

2 tbsp brown sugar (30 grams)

1 tbsp honey (20 ml)

1 tbsp butter (14 grams)

½ tsp ground ginger (2 grams)

2 tbsp Dijon mustard (30 ml)

2 salmon fillets

1 tbsp olive oil (15 ml)

NOTE It's best to buy fillets from the center of the fish, where the meat is thickest, preferably from wild-caught salmon. If the fish is thinner than 1 inch, cut the cooking and baking times in half.

SWEETS

IT'S PROBABLY SACRILEGIOUS TO SAY THIS, BUT I DON'T HAVE MUCH OF A SWEET TOOTH.
I'd choose savory over sweet any day of the week, but I do love to bake. For me, baking
is like math. You follow the rules and it works, and if doesn't work, you probably forgot
to carry the 1. Life is so confusing sometimes, and after thinking a lot about what went
wrong in my life or what I could have done differently, I've come to accept that there is
no formula for success. Everyone's path is different and what works for one person won't
necessarily work for another.

However, there is a formula for sweets, and the more you stick to the plan, the bet-
ter they will turn out. Yay! Of course, finding the right recipe is key. My mother-in-law,
Basia, has been perfecting her Chocolate Walnut Cake for more than 25 years! It was
a huge honor to watch her make this masterpiece (plus I had never tasted a flourless,
walnut-based cake before). And it was a good thing too, because I learned *sooo* much.

The secret to making a walnut cake is to use a rotary grater to shave the walnuts. Note
that I say *shave*, not *grind* or *chop*. Since this ingredient is replacing flour, it needs to be
able to absorb and bind the rest of the ingredients together. If you shave the walnuts,
you'll have a soft, moist base to build from, and unless you want to shave each walnut by
hand, you need to use this tool.

Another fascinating thing I learned from Basia was to use breadcrumbs not only in
the recipe, but also to prevent the cake from sticking to the cake form. You take butter
and really slather it on the cake form, and then add some breadcrumbs and roll the form
around until everything is evenly coated. It works a lot better than any kind of spray and
is a good precautionary ingredient to use even on nonstick pans.

Also, I don't know what I had imagined chocolate frosting was made out of (something
like liquid happiness or gold), but it's mostly butter and unsweetened cocoa. You have
a lot of control over how chocolaty you want it to be, but make sure you taste it as you
go because you may not need to add all the butter. As for the consistency, if you dip the
spoon in the mixture and lift up, it should slowly and evenly run off and taste like the
best chocolate frosting you've ever had.

Aside from being an art in itself, I think of baking as a form of therapy. Like medita-

tion, you can clear your mind and just focus on one thing—following the recipe. Are you having a bad day? Bake something. It will give you something to do besides be upset, and then you'll have something sweet to eat when you're done. Or, better yet, share it and make someone else's day, which I find has the power to change any dark and bitter mood for the better.

One of the best examples I can give of this food-sharing transformation took place during Thanksgiving one year. My family is on the East Coast and Piotr's is in Poland, so it was looking like a lonely dinner at home until my generous friends, Jan and Carrie, invited us to join their family celebration. They had rented a campsite in Thousand Oaks and planned on creating a giant Thanksgiving campout.

I was nervous about sleeping in a tent (I'm not a happy camper), but when we hiked to the site, the beautiful scenery and giant gathering stunned me. There was an enclosure made of stone, with a wood-fire hearth and cooktop (just like in old-timey cabins), BBQ pits, and tables of side dishes and sweets. One table held a big mound of oatmeal cookies. (And there were real restrooms with showers, phew!)

Such an amazing experience. I finally got to live out one of my dinner-gathering fantasies and ate some of the best oatmeal cookies I'd ever tasted. When we returned to reality on Monday, I could not stop thinking about those cookies, and asked for the recipe. Being the amazing and kind people they are, Jan and Carrie wrote out the recipe on the spot. It literally changed my life, and I'm excited to share it and other much-loved dessert recipes with you.

BAKING 101

In my opinion, baking is a lot easier than cooking. If you have the right measuring tools and know how to use them, then you are generally going to be a fantastic baker. Just follow the directions (seriously, do not improvise unless specified), and keep an eye on the time. It's as easy as pie. Yum!

Tips & Tricks

1 Read through the recipe from beginning to end before baking. This way, when you are mixing, you'll know roughly what will happen next.

2 Gather all your ingredients before you begin the first step. This is particularly useful because when baking, you typically want your ingredients at room temperature, especially the eggs and butter (unless otherwise specified). Some recipes require you to cream the butter. This means mixing the butter and sugar until the batter's light, airy, and fluffy— and that butter better be room temperature, or it won't cream properly.

3 Preheat your oven. I put this step early on in the recipe so you won't forget, but if your oven is still not fully heated by the time your dessert is ready to go in, be patient. That oven really needs to be the right temperature. Also, all ovens are created differently, so always check for doneness by using a toothpick or chopstick. Stick it in the center of the baked good, and if it comes out clean, then you're golden. If it comes out with some gooey paste, put the dessert back in the oven for another 3 to 5 minutes, then test again.

4 Use parchment paper or muffin liners in your baking pans. This will save sooo much time cleaning and scrubbing. I even like using parchment paper when I'm mixing or rolling out dough, for easier counter cleanup.

5 Use the right measuring tools and be as precise as possible. For liquids, use liquid measuring cups; for dry ingredients, use regular measuring cups. For a super precise measuring tool, use a scale. I also find it best to spoon the flour into the measuring cup and then level it with a knife, instead of scooping it all at once and then shaking off the excess.

6 It's a good idea to mix wet ingredients in one bowl and dry ingredients in a different bowl, then combine them afterwards. This helps prevent lumps and creates a more evenly distributed mixture.

7 Crack your eggs in cups or small bowls before adding to the batter. This is a precaution and can be skipped, but it really sucks to bite into an eggshell in a nice, moist cake.

8 When you're mixing egg whites until they form stiff peaks, this can take a lot longer than you expect. You will know when that happens, so keep going until then and be patient. What's the rush?

9 Baking powder and baking soda are very different ingredients. Seriously, don't mix these up. Also, these ingredients eventually expire, so check their dates.

10 Listen to some music and chill out. This is a time to relax.

BAKING CONVERSION CHARTS
For Dry Ingredients

1 Tablespoon = 3 teaspoons

⅛ cup = 2 Tablespoons

¼ cup = 4 Tablespoons

⅓ cup = 5 ⅓ Tablespoons

½ cup = 8 Tablespoons

⅔ cup = 10 ⅔ Tablespoons

¾ cup = 12 Tablespoons

1 cup = 16 Tablespoons

For Wet Ingredients

1 cup = 8 fluid ounces = ½ pint

2 cups = 16 fluid ounces = 1 pint

4 cups = 32 fluid ounces = 2 pints = 1 quart

8 cups = 64 fluid ounces = 4 pints

16 cups = 4 quarts = 128 fluid ounces = 1 gallon

PIE DOUGH

The key to making a good pie dough is to keep things cold! You don't want the dough to turn into a melted, soft mess, so don't bring your butter to room temperature—keep it in the refrigerator for as long as possible. The following recipe will make 2 9-inch pie crusts, which will keep in the refrigerator for up to 2 days or the freezer for 3 months.

INGREDIENTS

1 cup unsalted butter

2½ cups flour

½ tsp salt

½ tbsp sugar

¼ cup ice water

1 Chop the butter into small cubes, then lightly wrap and place back in the refrigerator.

2 Combine the flour, salt, and sugar in a large bowl and mix.

3 Get your water all icy and measured.

4 When you're ready to start mixing, remove the butter from the fridge and add it to the flour mixture.

5 Using two butter knives or a pastry cutter, cut the butter into the flour. (If using knives, just move the knives in opposite directions until well-combined and crumbly. This may take a while.)

6 Once the mixture looks like even-size crumbles, add the ice water and mix using your hands or a large spatula.

7 Form the dough into a ball.

8 Cut the dough in half, form into two balls, and flatten into two separate disc shapes. Wrap each disc individually in plastic wrap and refrigerate for at least 2 hours before rolling out and baking.

JAN'S OATMEAL COOKIES

MAKES: 25

DIRECTIONS

1 Preheat the oven to 350 °F (180 °C).

2 Combine all the dry ingredients in a large bowl. Add the wet ingredients and mix well so you get an evenly distributed batter.

3 Line a baking sheet with parchment paper.

4 Spoon the batter onto the baking sheet into quarter-size balls about 2 inches apart.

5 Bake each batch for 10 to 12 minutes.

INGREDIENTS

½ cup sugar

¼ cup brown sugar (55 grams)

¾ cup flour (96 grams)

1 cup rolled or old-fashioned oats (200 grams)

½ tsp baking soda (2 grams)

a pinch of sea salt

½ cup walnuts (100 grams)

½ cup mini baking chocolate chips (115 grams)

½ cup butter (slightly melted) (113 grams)

1 egg

½ tbsp vanilla extract (7 ml)

NOTE This is a very flexible recipe. It's easy to substitute or add/remove nuts, chocolate chips, raisins, etc. It's the consistency that you want to get right. Make sure that the batter:additive ratio is enough to hold all the ingredients together without being too liquidy. You should be able to form it into a ball and it should hold its shape.

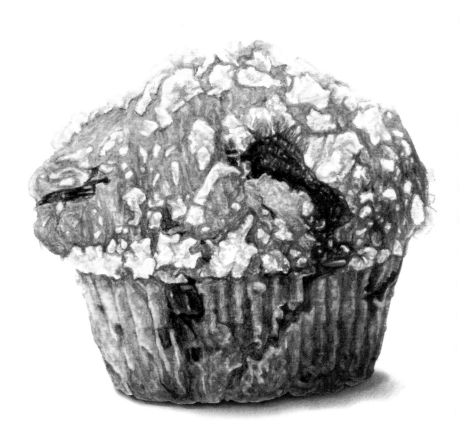

CRUMBLE-TOP MUFFINS

MAKES: 12

DIRECTIONS

1 Preheat the oven to 375 °F (190 °C).

2 Melt the butter in a pan or microwave.

3 Combine the melted butter, milk, eggs, vanilla, flour, sugar, baking powder, and salt. Mix well.

4 Gently add the blueberries, folding them into the batter.

5 Line a muffin pan with muffin liners (optional) or grease the muffin pan with oil or butter, and spoon the batter evenly into each cup.

6 In a small bowl, combine the flour, butter, and sugar for crumble. Using your hands, mix together into a crumbly, even texture.

7 Sprinkle this mixture on top of the muffin batter.

8 Bake for 20 minutes or until the tops are golden.

9 Let the muffins cool for 15 minutes.

INGREDIENTS

6 tbsp butter (84 grams)

⅓ cup milk (80 ml)

2 eggs

1 tsp vanilla extract (5 ml)

1½ cups flour (190 grams)

¾ cup sugar (150 grams)

1½ tsp baking powder (14 grams)

¾ tsp salt (3 grams)

1 cup fresh blueberries (220 grams)

FOR THE CRUMBLE

6 tbsp flour (48 grams)

2 tbsp butter (28 grams)

2 tbsp sugar (30 grams)

NOTE These muffins remind me of my childhood and the packaged streusel muffins that my best friend, Sheila, would make for breakfast when I slept over. It's the crumbly topping that makes this recipe so delicious. You can add this topping to other baked cakes and muffins too.

BLUEBERRY PIE

SERVES: 8

INGREDIENTS

2 small cartons fresh
blueberries (or 3–4 cups
frozen blueberries)
(250 grams)

2 Pie Dough sheets (pg 204)

¾ cup + ½ tsp sugar
(152 grams)

5 tbsp cornstarch (60 grams)

¼ tsp sea salt (1 gram)

½ tsp cinnamon (2 grams)

3 tbsp lemon juice (45 ml)

2 tbsp butter (28 grams)

1 egg white

DIRECTIONS

1 Rinse the blueberries and let them dry.

2 For the pie dough, make the recipe on page 000 or buy it frozen or in a mix. (You will need 2 pie dough sheets, for the top and bottom.)

3 Grease the pie pan with oil or butter and fit one sheet into the pie pan. For the latticework, cut the other sheet into ¾-inch strips.

4 Preheat the oven to 400 °F (200 °C).

5 In a large bowl, combine ¾ cup sugar with the cornstarch, sea salt, and cinnamon. Add the blueberries and lemon juice and mix well. Pour the blueberry mixture into the pie pan. Cut the butter into thin slices and place the pads, evenly spaced, on top of the filling.

6 Weave the dough strips together to make the latticework. (What I like to do is place the bottom layer of strips going one direction, then the top layer of strips going the other direction. Then, when they're in the right position, I weave both together going from one side to the other). Once done, cut the edges and crimp them closed using a fork.

7 Separate an egg, putting the yolk aside for a different use. Whisk the egg white. Lightly brush the egg white over the latticework and sprinkle a few pinches of sugar on top.

8 Cut aluminum foil into 2-inch strips and cover the edges of the pie to prevent it from burning.

9 Bake for 35 minutes, then remove the foil and continue baking for 15 minutes. Let the pie cool for 10 minutes before serving.

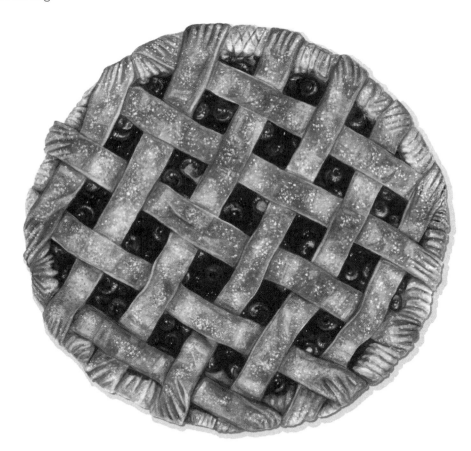

NOTE This recipe is amazing because it uses fresh blueberries. Unlike the berries in store-bought pies, these blueberries have a crispness to them that preservatives tend to destroy. If you use frozen blueberries, be sure to thaw them in a strainer so the liquids drain before adding to the pie, otherwise it will be soggy.

ITALIAN PEAR CAKE

SERVES: 6–8

DIRECTIONS

1 Preheat the oven to 350 °F (180 °C).

2 Melt the butter in a small saucepan.

3 In a large bowl, mix the eggs and sugar using an electric mixer.

4 Add the flour, baking powder, cornstarch, sea salt, and the melted butter. Mix well (about 2 to 3 minutes).

5 Pour the batter into a greased baking pan.

6 Peel the pears and cut into slices.

7 Place the pears into the batter and gently push them in. (It's okay if they stick out of the batter.)

8 Bake for 30 minutes. Let cool for 10 minutes.

9 Using a strainer, sprinkle some powdered sugar on top of the pear cake.

10 In a small bowl, whisk ¼ cup heavy cream with 3 to 4 tbsp powdered sugar to make a whipped cream (optional). Serve with coffee.

INGREDIENTS

½ cup butter (113 grams)

3 eggs

¾ cup sugar (150 grams)

1¼ cups flour (160 grams)

1 tbsp baking powder (12 grams)

¼ cup cornstarch (32 grams)

¼ tsp sea salt (1 gram)

2 overripe pears (any variety you like)

3–4 tbsp powdered sugar (36–48 grams)

¼ cup heavy cream (60 ml)

NOTE This is a foolproof cake. The pears add the perfect amount of refreshing fruitiness. You can use just about any pear variety or substitute apples for the pears. It is best when the pears are overripe, which makes the cake less sweet.

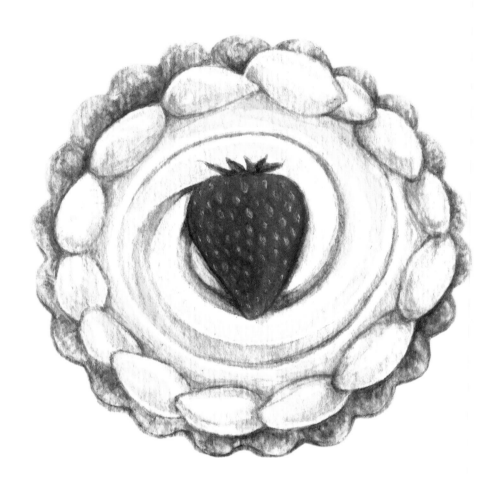

STRAWBERRY TARTS

SERVES: 6

DIRECTIONS

1 Finely chop the almonds. The pieces should be the size of breadcrumbs.

2 Mix the almonds, flour, butter, sugars, egg, and salt, combine into a ball, and cover in plastic wrap. Place in the refrigerator for 2 hours or more, but less than 1 day.

3 Remove the dough from the fridge. Using your fingers, pull off pieces and squish the dough into tart pans, following the form and creating an even thickness throughout.

4 Place the tart shells in the freezer for 30 minutes, to prevent the dough from shrinking once baked.

5 Preheat the oven to 350 °F (180 °C).

6 Bake for about 10 to 15 minutes. This may take more or less time, depending on the size of the tart pans and thickness of the dough. Watch carefully and remove from the oven when they look golden, but not brown. Let them cool for 5 minutes.

7 Remove the tarts from the tart pans.

8 For a fancy presentation, place your favorite Greek yogurt in a large Ziploc bag and cut the tip of a corner to create a piping bag. Fill with the yogurt and top with a fresh strawberry or any kind of fruit you prefer.

INGREDIENTS

¼ cup chopped almonds
 (35 grams)

1 cup flour (128 grams)

⅓ cup butter (76 grams)

1 tbsp granulated sugar
 (15 grams)

2 tbsp confectioners' sugar
 (30 grams)

1 egg

a pinch of salt

2 cups Greek yogurt (480 ml)

3 strawberries

NOTE Once the tarts are baked and removed from the pans, they will keep in an airtight container for up to 3 days. You can also fill them with whipped cream, custard, or other fruits.

BANANA BREAD

MAKES: 1 LOAF

DIRECTIONS

1 Preheat the oven to 350 °F (180 °C).

2 Cream the butter and sugar using an electric mixer or a spoon until soft and smooth.

3 Mash the bananas using a fork.

4 Add the eggs, mashed bananas, flour, salt, baking soda, walnuts, and raisins to the creamed sugar and stir well.

5 Coat a bread pan with butter, to prevent the bread from sticking to the sides, and pour the batter into the pan.

6 Cover with aluminum foil and bake for 1 hour. Let cool for at least 15 minutes.

INGREDIENTS

½ cup butter (113 grams)

1 cup sugar (200 grams)

2 old, browned bananas

2 eggs

1¼ cups flour (160 grams)

½ tsp salt (2 grams)

1 tsp baking soda (4 grams)

¼ cup walnuts (60 grams)

¼ cup raisins (60 grams)

NOTE The key to this recipe is to use overripe bananas. The browner the banana, the better, because they are easier to mash and sweeter. "Creaming" the butter and sugar means to combine these ingredients until you have a fluffy, aerated, yellow mixture. Just don't overmix or the butter will start to separate.

BASIA'S CHOCOLATE WALNUT CAKE

SERVES: 8

INGREDIENTS

2 cups fresh or frozen cherries
(500 grams)

2 cups vodka (480 ml)

2 cups walnuts (400 grams)

4 tbsp breadcrumbs + extra for
the pan (60 grams)

8 eggs

1 large lemon

1 cup powdered sugar
(128 grams)

1 tbsp vanilla extract (15 ml)

butter for cake form

cake pan with removable
bottom

FOR THE FILLING

½ cup unsalted butter
(113 grams)

2 eggs

6–7 tbsp powdered sugar
(72–84 grams)

7 tbsp unsweetened cocoa
(84 grams)

2 tbsp milk (30 ml)

fresh raspberries

FOR THE CAKE:

1 The night before you make this cake, place fresh or frozen cherries in a small jar and cover with—what else, it's a Polish recipe—vodka.

2 Preheat the oven to 350 °F (180 °C).

3 Finely shave the walnuts, using a rotary cheese grater, into a large bowl. Add the breadcrumbs to the walnuts and stir. In two large bowls, separate the egg whites from the egg yolks. Zest the lemon into a cup and add the juice of half a lemon. Add the powdered sugar to the egg yolks and whisk using an electric mixer. Then add the lemon zest, lemon juice, and vanilla, and mix well.

4 Beat the egg whites using an electric mixer until stiff peaks form. Slowly and gently, add the egg whites to the walnut mixture. (Make sure you don't transfer any of the excess water from the egg whites.) Add the egg yolk mixture, using a spoon to gently stir until well-combined.

5 Generously butter the cake form, then add a spoonful or two of breadcrumbs and swish them around so the entire pan is coated. (This will allow the cake to come out of the form smoothly). Pour the batter into the cake form and bake for 30 to 35 minutes. Then turn off the heat, crack the oven door, and let it cool on the rack for 30 minutes.

FOR THE CHOCOLATE FILLING AND TOPPING:

1 Remove the sides of the cake pan and let the cake cool completely. Carefully slice the cake in half horizontally, so you have two layers.

2 Melt the butter in a small saucepan and let it cool to room temperature.

3 In a large bowl, mix the eggs, powdered sugar, unsweetened cocoa, and milk, using an electric mixer. Slowly add the butter to the cocoa mixture, noting the consistency (smooth) and color (rich brown). Be sure to taste frequently because you may not need to add all the butter.

4 To assemble, position one layer of the cake with the cut side up and spoon the chocolate on top. Drain the vodka-soaked cherries and add a layer on top of the chocolate. Add more chocolate so that you have a good-sized layer. Cover with the other layer of the cake (with the cut side down). Using a knife, cover the top and sides with chocolate to get a smooth surface.

5 Refrigerate for 2 to 4 hours. Add some powdered sugar and fresh raspberries on top and serve with coffee.

CHALKA

MAKES: 2 LOAVES

INGREDIENTS

½ cup butter (113 grams)

1 cup warm milk (240 ml)

1 cup sugar (200 grams)

½ tsp salt (2 grams)

2 eggs

4 tsp active dry yeast
 (12 grams)

1 cup raisins (250 grams)

5½ cups flour (768 grams) +
 extra flour to knead dough

olive oil (a few drops)

1 egg white

DIRECTIONS

1 Combine the butter, warm milk (no hotter than 110 °F [43 °C]), sugar, salt, and eggs in a large bowl. Mix well.

2 Dissolve the active dry yeast in ¼ cup warm water (no hotter than 110 °F [43 °C]), then add to the batter.

3 Add the raisins and flour (a few cups at a time) and mix with a spoon or your hands for 5 minutes until it's even. (The dough will be sticky).

4 Roll into a ball, place in the bowl, and cover. Let it rise for 1 hour (or until it has doubled in size) at room temperature.

5 Prepare a floured surface and knead the dough for 5 minutes. Divide the dough into 3 equal parts and roll each into a long log, about 2 to 3 inches in diameter.

6 Braid together in one long piece, then cut in half to create 2 equal-size loaves. Pinch and tuck the ends closed and place on a parchment-lined baking sheet.

7 Rub both loaves with a few drops of olive oil, cover in plastic wrap, and let rise for 30 minutes or until they have doubled in size.

8 Preheat the oven to 350 °F (180 °C).

9 Separate an egg, putting the yolk aside for a different use. In a bowl, whisk the egg white, and then spread it on top of the chalka dough using a pastry brush. (This will create a nice golden crust.)

10 Bake for 30 minutes. Let the loaves cool for 15 minutes before slicing.

NOTE Chalka (pronounced how-kah) is a traditional Polish braided sweet bread. This recipe makes two very large loafs and is a forgiving bread to bake. It's also great for making French toast for the French Toast & Crispy Bacon (pg 37) or bread pudding. It can be sliced and stored in the freezer for up to 1 month.

BIRTHDAY CAKE

SERVES: 10–12

INGREDIENTS

2 tbsp lemon zest (30 grams)

1 tbsp lemon juice (15 ml)

1 cup salted butter (227 grams) (and more to coat the cake pan)

1½ cups sugar (300 grams)

4 eggs

2½ cups flour (315 grams)

¼ tsp salt (1 gram)

4 tsp baking powder (16 grams)

1 cup milk (240 ml)

¼ cup breadcrumbs (55 grams)

FROSTING

2 cups unsalted butter (454 grams)

6 cups powdered sugar (1.2 kg)

½–1 cup fresh strawberries + extra to decorate (250 grams)

2–3 tbsp lemon zest (30–45 grams)

a pinch of salt

1 tsp vanilla extract (5 ml)

DIRECTIONS

1 Take all the cake ingredients out of the refrigerator and wait until they are at room temperature.

2 Preheat the oven to 350 °F (180 °C).

3 Zest the lemon and squeeze the lemon juice into a cup.

4 Cream the butter and sugar until fluffy.

5 Separate the eggs and add the egg yolks to the butter-sugar mixture and the egg whites in a medium-size bowl.

6 Using an electric mixer, mix the egg yolks into the butter-sugar mixture. Add the flour, salt, baking powder, milk, lemon juice, and lemon zest. Mix thoroughly.

7 Whisk the egg whites until stiff peaks form and, using a spoon, gently fold into the batter. (Make sure not to add any excess water from the eggs.)

8 Liberally coat the cake form with butter on the bottom and sides. Pour in the breadcrumbs and roll the pan until it's completely coated. (This will prevent the cake from sticking.)

9 Bake for 1 hour or until the top is golden and the middle is firm. (If you stick a toothpick in the center, it should come out clean.)

10 Let cool for 1 hour or more before removing from the cake pan. Cut the cake in halves or thirds, depending on your cake pan size.

11 About an hour before you are ready to make the frosting, remove the butter from the refrigerator and bring to room temperature.

12 In a large bowl, beat the butter until light and fluffy. Slowly add the powdered sugar and whip until well-combined.

13 In a blender, purée the strawberries, and zest 1 to 2 lemons.

14 Add a pinch of salt, the lemon zest, vanilla extract, and puréed strawberries to the butter-sugar mixture. (Note: The more strawberries you use, the pinker the frosting will become.) Then divide the frosting in half.

15 Place the bottom cake layer cut-side up, then add a layer of frosting. Cover with the top cake layer cut-side down, and repeat the previous step if there is a third layer.

16 Use the other half of the frosting to coat the entire cake's sides and top.

17 Refrigerate for 1 hour or more to stiffen, then decorate with strawberries.

AMY'S MOLASSES CRINKLES

MAKES: 36 COOKIES

DIRECTIONS

1 In a large bowl, mix the shortening, 1 cup sugar, egg, and molasses.

2 In a separate bowl, combine the flour, baking soda, salt, cloves, cinnamon, and ginger.

3 Add the wet ingredients to the dry and mix until well-combined.

4 Cover in plastic wrap and refrigerate for 1 to 3 hours.

5 Preheat the oven to 350 °F (180 °C).

6 Roll the dough into small balls, each the size of a penny.

7 Sprinkle 1 tablespoon of sugar on a plate and roll the dough balls in the sugar.

8 Line a baking sheet with parchment paper, put the dough balls on the sheet, and bake for 10 to 12 minutes.

INGREDIENTS

¾ cup shortening (145 grams)

1 cup + 1 tbsp sugar
 (215 grams)

1 egg

¼ cup molasses (85 grams)

2 cups flour (256 grams)

2 tsp baking soda (8 grams)

¼ tsp salt (1 gram)

½ tsp ground cloves (2 grams)

1 tsp cinnamon (4 grams)

1 tsp ground ginger (4 grams)

NOTE My dear friend and talented baker, Amy, makes the best molasses crinkles I have ever tasted! Unlike the dense and chewy molasses cookies sold in cafes, these cookies are soft and oh-so-addictive. They also make the perfect holiday treat/present and will keep for 1 month in an airtight container.

DRINKS

LEARNING ABOUT DRINKS WAS A BIT OF A CHALLENGE FOR ME. MY PERSONAL JOURNEY INTO the world of cooking started very late, and aside from drinking copious amounts of coffee, tea, beer, and wine, I was not discerning or knowledgeable about mixed drinks or hard alcohol. Growing up, I don't ever remember seeing my parents drink. The closest substance to alcohol in my house was champagne on New Year's Eve, which I thought was disgusting.

So, it was no surprise that when I set out for college and started experimenting with poisons, I realized that coffee was the elixir of life, and drinking alcohol was fun and chilled me out. Only after a few years of drinking coffee every day did I started appreciating the better/stronger kinds and acquire a taste for certain beans and roasts (thank you, Seattle).

With alcohol, it was even longer before I started noticing the differences between wines, besides the color. Or realized that IPA was not pronounced "eepa." It simply takes time and hundreds of bottles of wine to recognize the good inexpensive white from the just cheap kind. I think that *aha* moment came when I decided to buy my favorite Bordeaux in cases rather than by the bottle. And then I got a wine rack, which was a step toward full adulthood.

Still, mixed drinks riddled me. Sometimes I ordered a drink at one bar and loved it, and then ordered that same drink at a different bar and hated it. Eventually I realized that the quality of the alcohol used to mix the drink makes all the difference. Not that you have to buy really expensive drinks, but if you don't want a hangover the next day, you better ask the bartender for the better version of that drink and pay the few extra bucks.

Then, at some point during my travels, I had a chance to taste a really good, aged whiskey, and concluded that a 20-year-old reserve is my drink of choice. Fortunately for my liver and general health, I could not afford a lot of it, so on principle I stopped drinking the cheap stuff and saved up for a bottle of something really good.

It goes without saying that I have discovered a difference in lifestyle between quantity and quality. As I started collecting for my home bar, I began to learn about other alcohols and the ways of mixing. It doesn't take many bottles to create a diverse drink list. My ever-rotating collection consists of only 10 bottles that I frequently restock and a few secret

bottles that I lock up with my jewelry. The basic bottles are: a good bourbon, some quality whiskey, tequila, dry gin, brandy, a white and a dark rum, dry vermouth, orange bitters, and Cointreau.

These can be combined in so many wonderful ways that the party never gets boring. There are a few very nice benefits to drinking at home with or without friends instead of out at bars—no need for transportation, larger quantities of alcohol for way less money, and no disgusting bathrooms to avoid. Once you learn how much a good bottle of alcohol costs in comparison to how much you're paying for a drink using crap ingredients at a bar, you'll be shocked, and you'll probably need to change your drinking habits.

However, as with everything else in life, use moderation. Or else buy the most expensive alcohol you can, so you'll appreciate it. And for a way to mediate that hangover, try some healthy juices. I had reservations about the juicing craze until I bought a blender that could chew through an avocado pit. Since then I have been experimenting with fresh vegetables and fruits, and feeling better for it. Just about everything in the produce section can be made liquid and tastes great.

I'm still working on the ultimate drink recipe. How fun would it be to get your fiber and alcohol all at once? Not there yet, but here are some notable drinks, from morning coffee and a breakfast smoothie to the late night old-fashioned. Remember to get quality ingredients for whatever you are brewing/stirring, and don't be afraid to mix it up.

KEEP POURING . . .

Before I get to the juicy and boozy recipes, I think it is worth mentioning my two constant drink companions: tea and coffee. They wake me up, keep me going, and then put me to sleep. What more can one want from a beverage?

Intro to Tea: For millennia (the earliest tea records in China date to the 10th century BC), we humans have been adding various leaves to hot water and drinking it. I was introduced to tea brewing in the same way as most American kids, via the small bag at the end of a

string. It's a good way to start, especially now, with the giant aisle of options at groceries and pharmacies alike. However, once you go loose leaf, it's hard to go back.

Tea brewing can be as simple or as complicated as you wish—from choosing a flavor that sounds interesting to the stunningly beautiful Japanese tea ceremonies. The best advice is to learn what types of tea you like via tea bags, then visit a tea shop and try the loose leaf version. Often, these shops will allow you to smell, touch, and taste the tea before you buy it, and are a great source of knowledge.

Here's What You Need to Brew Loose Leaf Tea:

- A teapot with a fine mesh, a French press, or any other device that would allow you to slow brew: The larger the pot, the longer the water stays warm, so for small pots, consider ceramic options or invest in a tea cozy.
- Boiling water: Ok, this is easily achievable in many ways. I like to use an electric kettle—I splurged one Christmas and got a high-end one that I think runs on plutonium, because it can boil water in less than 2 minutes. Totally worth it. If you want to take it to the next level, remember that green tea should be brewed with water below the boiling point.
- Trimmings: Depends on your taste and cultural background. Things like sugar, milk, lemon, honey, agave . . . you name it.
- Cups for all occasions, from a favorite "I'm cold and need to warm my hands with a big ceramic mug I got at a garage sale" to the perfectly matched set of porcelain cups for a spring tea party.
- The tea: I started my collection by buying loose leaf teas from different parts of the world. It's amazing to taste the difference between an Indian-grown Assam and a Chinese oolong. Once I had acquired a few varieties of black, green, and herbal teas, I started to mix them experimentally. And the amazing part is that you can rarely go wrong. The taste can vary from a bitter green to a sweet and fruity hibiscus (which is actually a flower), so mix and match to suit your mood.

MY PERFECT CUP OF TEA

1 Place 1 teaspoon (no pun intended) of black aged tea such as Yunnan, and 2 teaspoons of something lighter like an Amba Ceylon in a teapot. Add 3 cups of boiling water, cover, and let it steep for 5 minutes.

2 Pour into a cup and add a thin slice of lemon (no squeezing, just throw it in there) and 1 tablespoon sugar. (Watch the tea change color when you add the lemon—the acidity of the lemon reacts with the tannins in the tea; it also cuts down the bitterness.)

3 Enjoy!

INTRO TO COFFEE

There is so much commercially available coffee these days, it's hard to decide on one's favorite. Start with different origins and go on to fresh roasts—almost all good grocery stores either carry locally roasted coffee or roast the beans themselves.

I'm partial to anything marked "fair trade." The wonderful beans that come to us from the farmers from all over the world have a chance to improve someone's life one cup at a time. Sign me up!

Similar to tea, the method of brewing coffee can be as complex as you wish to make it. Starting with Turkish coffee (boil ground coffee in a small pot with water and serve unfiltered in a cup) and working your way through countless methods of drip, percolating, and up to an espresso machine, everyone should find their favorite niche.

I'm somewhere in the middle of the brew spectrum, with a stove-top espresso pot. It's an Italian contraption that my designer husband loves for its historical contribution to the world of industrial design. I love it because it makes two super-strong cups of thick coffee with good crema on top. Crema is the gold foam on top of the espresso that appears if the pressure/temperature is just right.

The main factor in quality coffee, just like with many other foods, is the freshness of the ingredients (well, in this case, one ingredient)—mainly, how long ago the beans have been ground. If there is one improvement you can make to the taste of a coffee, it is to grind it right before you use it. This supposes you like to make your coffee fresh and not substitute the instant/capsules/whatever method.

There is nothing wrong with instant coffee (if there's nothing else available it's the perfect fix). However, for home use I strongly recommend taking the extra five minutes and going through the strenuous labor of making that perfect cup from scratch.

Coffee does so much—it's nice to appreciate it.

MY PERFECT MORNING CUP

A cup of really strong espresso coffee with just a splash of boiling water to dilute it gently. Usually I like to add half and half and a drop of vanilla, especially if my coffee beans are a dark roast.

IRISH COFFEE

SERVES: 1

DIRECTIONS

1 Using a hand mixer, whip the heavy cream and confectioners' sugar for 4 to 5 minutes until fluffy.

2 Make 2 strong espresso shots.

3 In a glass, add the brown sugar, Irish whiskey, and espresso. Stir. Top with fresh whipped cream.

4 Sprinkle with grated dark chocolate.

INGREDIENTS

½ cup heavy cream (120 ml)

1 tbsp confectioners' sugar (15 grams)

2 shots hot, fresh espresso (90ml)

1 tsp brown sugar (4 grams)

1 shot Irish whiskey (50ml)

dark chocolate

NOTE This is pretty much an *espresso con panna* with good booze added. As such, it serves two functions: It gets you up and going as it makes you happy and relaxed. It's essential for winter vacations and cold days on the couch with a book.

QUINCE TEA

MAKES: 10–20 GLASSES

DIRECTIONS

1 Wash the quinces, then peel and remove the cores and seeds.

2 Using a grater, shred the quinces.

3 In a large bowl, combine the shredded quince and the sugar and let it sit for 2 hours at room temperature.

4 Pour into a saucepan and bring to a boil. Add the honey, stir, and simmer for 30 minutes.

5 Wait until the mixture has cooled, then refrigerate. Use for up to 1 week.

6 To enjoy a quince tea, place 1 to 2 tablespoons of this quince syrup (including the quince pulp) in a cup and add boiling water. Let it steep for 3 to 5 minutes, then enjoy.

INGREDIENTS

2 large quinces
1 cup sugar (200 grams)
½ cup honey (125 ml)
boiling water

NOTE I learned about the existence of quince tea in Korea. It was a bit of surprise when one of my cousins handed me what looked like a mug of hot water and I found it tasted sweet and fruity. When I returned home, this concentrate was almost impossible to find, but the quince fruit was available.

HEALTHY SMOOTHIES

SERVES: 1 (PER RECIPE)

DIRECTIONS

1 Wash the fresh fruit and vegetables as needed.

2 In a blender, combine the ingredients and purée.

3 Add water (if you would like a thinner drink) and/or ice as desired.

SMOOTHIE #1
INGREDIENTS

1 cup almond milk (240 ml)

1 banana

½ cup frozen berries (100 grams)

1 tsp peanut butter (3.5 grams)

1 apple, cored

4 dates, pitted

3 cups spinach (720 grams)

SMOOTHIE #2
INGREDIENTS

1 cup orange juice (240 ml) or 2 oranges

½ cucumber

1 Ambrosia apple, cored

3 cups spinach (720 grams)

SMOOTHIE #3
INGREDIENTS

½ to ¾ cup water

2 cups chopped kale

1 banana

1 apple, cored

1 pear

3 candied pineapple slices

NOTE The key to a successful juice starts with properly stacking your ingredients in the blender. The liquids and fruit (such as apples or oranges) should be on the bottom, followed by soft or leafy fruits and vegetables (bananas, spinach), and then anything else. Top it off with the ice. This will assure quick blending and a smooth drink.

MOJITO

SERVES: 1

INGREDIENTS

a handful fresh mint

2½ tsp brown sugar
 (500 grams)

½ lime

1½ shots white rum (75ml)

3–4 ice cubes

carbonated or sparkling water
 (like San Pellegrino)

DIRECTIONS

1 In a tall glass, muddle (crush with a blunt object) the mint, brown sugar, and juice from ½ a lime.

2 Measure and add the white rum and 3 to 4 ice cubes.

3 Add a few uncrushed mint leaves and lime slices, for visual flavor.

4 Slowly fill the rest of the glass with the carbonated or sparkling water, pouring it on the ice so it doesn't muddy the drink.

5 Enjoy!

NOTE Since the mojito is an essential summer drink, I sometimes run out of the prescribed ingredients and have to resort to improvising. I have substituted tonic for the carbonated water or used basil instead of mint. Both of these combinations taste great as long as you keep the rum/lime/sugar ratio intact.

BERRY MARGARITA

SERVES: 1

DIRECTIONS

1 Rub the rim of a glass with some lime juice and dip it into a plate of sugar.

2 Add the brown sugar and frozen blueberries to the glass and muddle.

3 Add your tequila of choice and the Cointreau and stir.

4 Add a few cubes of ice and top off the glass with carbonated or sparkling water.

5 Garnish with a lime slice and fresh mint.

INGREDIENTS

½ lime

1 tsp sugar (4 grams)

1 tsp brown sugar (4 grams)

⅓ cup frozen blueberries (70 grams)

1 shot tequila (Reposado or Anejo) (50 ml)

½ shot Cointreau (25 ml)

3–4 ice cubes

carbonated or sparkling water (like San Pellegrino)

fresh mint

NOTE This recipe works great as a hand-mixed or blended drink. For a blended version, you don't need to add ice since the blueberries are frozen. I use 1½ cups of frozen berries per drink. Keep the other ingredients the same, and only add carbonated water if the drink is too thick to pour.

HOMEMADE LEMONADE

MAKES: 1 LARGE PITCHER

INGREDIENTS

1¾ cups sugar (350 grams)

1 cup hot water (240 ml)

4–5 lemons

8 cups cold water (1.4 L)

ice cubes

fresh mint (optional)

DIRECTIONS

1 To make a simple syrup, combine the sugar with the water and bring to a boil in a saucepan over high heat.

2 Lower to a simmer and stir until the sugar has dissolved, then remove from the heat and let it cool completely.

3 Squeeze the lemons to make 1½ cups of juice.

4 Combine the simple syrup, lemon juice, and cold water.

5 Add ice as desired and a few lemon slices and fresh mint (optional).

NOTE When life gives you limes instead of lemons, this drink recipe works just as well. To kick it up a notch, slowly pour a shot of dark rum on the top. It will layer beautifully, making a very attractive drink—just don't sell it on the front lawn for 50 cents a glass. It's worth at least $3.

SANGRIA

MAKES: 1 LARGE PITCHER

DIRECTIONS

1 Roughly chop or slice the fruit.

2 Add the sugar, brandy, orange liqueur, fruit, and bottle of wine to a pitcher.

3 Stir and cover with plastic wrap. Refrigerate overnight.

4 Serve straight or diluted with carbonated or tonic water.

INGREDIENTS

5–8 strawberries

1 apple

1 orange

2 limes

¼ cup sugar (55 grams)

1 cup brandy (240 ml)

¼ cup orange liqueur (60 ml)

1 bottle red or white wine

carbonated or tonic water

NOTE If you are for some reason not able to finish this drink right away, it will last in the fridge for an extra day. The longer it sits, the better it will be. To make this a traditional Spanish drink, use Grenache or another medium-bodied red wine.

LYCHEE MARTINI

SERVES: 1

INGREDIENTS

3 fresh lychees

a handful of ice

1 shot dry gin (50 ml)

½ shot dry vermouth (25 ml)

a splash of orange bitters

DIRECTIONS

1 Cut the tops off the lychees and remove the skin. Slice one side of the lychee and remove the pit. (Try to keep the lychee as whole as possible).

2 Squeeze one of the lychees into a martini shaker and add a handful of ice, the gin, and the vermouth.

3 Shake well for 30 seconds to make it cold.

4 Add a splash of orange bitters to the martini glass, then strain the liquids into the glass.

5 Spear the remaining two lychees on a toothpick, put them in the drink, and serve.

NOTE As you can tell by the recipe above, I go for the 007 method and shake the drink with ice. This makes it really cold really quickly. Also as long as the "-tini" part (gin and vermouth) remains constant, you can experiment with different fruits or an olive on a toothpick. And if you can't find fresh lychees, you can always use the canned version.

CLASSIC OLD-FASHIONED

SERVES: 1

DIRECTIONS

1 Remove a strip of peel from the orange for the garnish and quarter the orange.

2 Put the brown sugar in a glass.

3 Drip the orange bitters on the sugar until it is saturated.

4 Add the quartered orange on top of the sugar and muddle the pulp parts only (not the peel) until the sugar is dissolved.

5 Add ½ shot bourbon and stir.

6 Add a few ice cubes and stir.

7 Pour another ½ shot bourbon and stir.

8 Rub the rim of the glass with the orange side of the peel, add it to the glass as a garnish, and serve cold.

INGREDIENTS

¼ orange

½ tbsp brown sugar

a few drops of orange bitters

1 shot bourbon (50 ml)

a few ice cubes

NOTE The really awesome part about this recipe is that its complex taste can change with the type of bourbon you use. Some of my friends think I'm crazy because I use a 15-year-old oak-aged whiskey, but I can assure you that once you try this with a quality booze as a base, you will have a hard time going back to the cheap stuff. This is one of the drinks that really calls for quality, not quantity.

ONE-EGG EGGNOG

SERVES: 1

DIRECTIONS

1 Separate an egg and place the yolk in a small cup, putting the white aside for a different use. Add the sugar to the cup and whisk until smooth and well-combined.

2 Add the milk, cream, and nutmeg. Mix well.

3 Add the bourbon and Cointreau and stir.

4 Shave a sliver of an orange peel, fold over the edge of a glass, and rub the orange side of the peel on the rim (to add a citrusy smell to the drink).

5 Pour the eggnog into the glass and sprinkle with some nutmeg to finish.

6 Serve immediately.

INGREDIENTS

1 egg yolk

1½ tbsp sugar (22 grams)

½ cup milk (120 ml)

¼ cup heavy cream (60 ml)

¼ tsp nutmeg (1 gram)

1 shot bourbon (44 ml)

½ tsp Cointreau (3 ml)

shaved orange peel

NOTE This drink relies heavily on the freshness of the egg. The store-bought versions are pasteurized, but this recipe uses raw eggs, so buy the freshest eggs, preferably free-range eggs from grain-fed chickens. (Happy hens lay better eggs.) Oh, and drink this quickly; don't let it sit around. Cheers!

WHERE I ENDED UP

AS SOMEONE WHO HAS STRUGGLED WITH EXPRESSING HERSELF, WHETHER THROUGH ART, writing, speaking, or even knowing what it is she's thinking about, this cookbook has been a trial of communication—a way to see both past and present and make sense of my life through the medium of food. Had I known, when I left home for college, the importance of learning how to cook, slow down, and take care of myself, maybe I would have reached my implied notion of success and . . .

Ok, I laugh just thinking about it. I was doomed from the start, as we all are with such ideas of a straight path and infinite future. One that doesn't hiccup, zigzag, bounce around, and land somewhere unexpected. It is that giant gap between one's expectations and one's reality that has to be navigated. And you're lucky if you find an outlet to pour your craziness into and have it reward you with something good to eat afterwards.

At the time when everything was falling apart, I was far from laughing or even remembering what a joke was, but now, after examining and documenting my journey, I can say that it was all worth it. For me, very little of what I had imagined as a child has happened, art being the one exception. Food never factored in, but had I kept to my self-imposed fantasy, I would have missed out on a much better reality.

Plans only go so far. In the end, you have to trust yourself, not just in making decisions, but deep down, in the person that you are, and the things you know you are capable of doing. The ability to take care of yourself is one of the few forms of real security in this adult world. When all is said and drawn and written down in permanent ink, I feel at home in my body, having found a balance between doing and being. Food was my medicine and I feel satisfied with who I am. I hope you will too. Thank you for reading and cooking with me.

CULINARY TERMS

THE MORE YOU GET INTO COOKING, THE MORE YOU WILL SEE CERTAIN FOREIGN WORDS USED to connote a technique or style of dish. This can be frustrating and alienating, but don't let it affect you. Most of these phases are just French or Italian words that translate into something very simple.

À la carte (ah lah kahrt) A French phrase that means "according to the menu" (in other words, individually priced). You can also use this term to order an item from the menu by itself. If you want a steak with no side dishes, say, "steak à la carte."

Al dente (ahl den-te) An Italian phrase that means "to the tooth." It is used to describe a firm texture for cooked pasta, vegetables, rice, or beans. This doesn't mean undercooked, but cooked through until firm or until it can no longer be considered raw.

Al forno (ahl for-noh) An Italian phrase that means "baked." It is used for baked dishes or pasta dishes that are boiled then baked.

Alfresco (ahl-fres-koh) An Italian word that means "in the fresh." It references eating outdoors in the fresh air.

Antipasti (ahn-tee-pah-stee) An Italian word that means "before the meal." It refers to food served at the beginning of a meal either as a starter, appetizer, or snack, but typically something cold, like cheese and cold cuts, pasta salad, bruschetta, etc.

Apéritif (uh-per-uh-teef) A French term based on the Latin word "aperire," which means "to open." This is an alcoholic drink served before the meal. There is also the "digestif"—the same idea, only served after the meal to assist with digestion.

Aromatics These are combinations of vegetables and herbs cooked in some fat or oil at the beginning of a dish to impart deep flavors and aromas.

Basting A cooking technique which involves pouring juices, melted fat, or a sauce over food during the cooking process to keep it moist and allow it to absorb more flavor.

Béchamel (bay-shuh-mel) A French term for a white sauce made from a roux (butter and flour) and milk.

Blanch The cooking process of plunging fruits or vegetables into boiling water for a brief time, then submerging them in ice water to halt the cooking process.

Bouquet Garni (boo-kay gahr-nee) A French term for "garnished bouquet," which is a bundle of herbs tied together or wrapped in cheesecloth and used when making stocks and stews. It is not consumed and only used as a flavor enhancer.

Brine A solution of salt (and sometimes sugar) in water. Used like a marinade, it rehydrates the muscles in meat before cooking and creates moist, tastier meat.

Brûlée (broo-lay) A French term for burning or caramelizing the sugar on the surface of a food. Think crème brûlée.

Brunoise (broon-wahz) A French term for small, uniformly chopped vegetables.

Charcuterie (shahr-koo-tuh-ree) A French term for the collection or cooking of prepared meats (cold cuts, pâtés, etc.).

Chiffonade (chi-fuh-nayd) A French term for chopping herbs or greens by stacking or rolling and cutting into long, thin strips.

Clarified A food that has been filtered or rendered (heated and cooked) to remove impurities.

Compote A French term for "mixture" but also a dessert or drink made from cooking fruits in sugar syrup and spices.

Confit (kon-fee) A French term for cooking food in grease, oil, or syrup at a low temperature for a long time, often to preserve.

Consommé (con-som-may) A clear soup (made from stock or bouillon) that has been clarified.

Deglazing A technique where liquid is added to a pan and food particles are loosened and dissolved.

Emulsion A mixture of two ingredients that would not naturally mix together, such as oil and vinegar creating a simple vinaigrette, or egg yolks and oil creating mayonnaise.

Flambé (flahm-bey) A French cooking process in which alcohol is added to a hot pan to create a flame.

Foie Gras (fwa grah) A French term for "fat liver," usually the liver of a specially bred and fattened duck or goose.

Fond (fahn) A French term for "bottom," referring to the dislodged roasted bits from a pan that has been deglazed.

Hors d'Oeuvre (or durv) A French term for an appetizer or starter.

Julienne A cutting method that results in food cut into long, thin strips.

Liaison A mixture of egg yolks and heavy cream used to thicken a sauce.

Mirepoix (meer-pwah) A chopped mixture of onions, carrots, and celery, used as the flavor base for many soups and sauces.

Mise en Place (mee zohn plas) A French term which means "set in place" and refers to having all of one's ingredients prepped before cooking.

Panade (pah-nad) Bread soaked in milk; used to moisten meats, also refers to bread soup.

Pane (pah-neh) To pass/coat food in seasoned flour, beaten egg, and breadcrumbs.

Pâté (pa-tey) A French term for a mixture of cooked ground meat minced into a spreadable paste.

Persillade (per-see-yahd) A mixture of parsley and seasonings such as garlic, herbs, and olive oil.

Poussin, (poo-sahn) a.k.a. "coquelet" A butcher's term for a young chicken that is less than 28 days old.

Râteau (rah-too) A French word for a wooden rake used to spread crêpes and galettes on the pan.

Roux (roo) A mixture of equal parts flour and melted butter, used as a thickening agent for soups and sauces.

Score To cut lines or indentations into meat or bread to help food absorb more flavors and/or cook faster.

Season To add salt, pepper, herbs and/or spices to food.

Skim To remove the scum or fat from the surface of a liquid using a strainer or spoon.

Truss To tie, sew, or bind meat using a string, creating a compact shape so it can be evenly cooked.

ABOUT SARA

SARA ZIN WAS BORN IN SEOUL, SOUTH KOREA, AND RAISED IN BUFFALO, NEW YORK. SHE began her art career at the College for Creative Studies in Detroit, where she studied illustration, design, and painting. She later transferred to the University of Washington, where she received her degree in Interdisciplinary Visual Art. After graduating, she started showing at the Pacini Lubel Gallery, in Seattle, and was awarded the GAP grant. She has exhibited at the Seattle Center Exhibition, Elliott Fouts Gallery, Jacob Lawrence Gallery, Gage Academy of Art, Con Artist, Sylvia White Gallery, Art Basel Miami Beach, and various other galleries across the United States.

Alongside her painting career, she also worked as a graphic designer at Smith-Harmon (an email marketing consultancy) and later at Responsys (an interactive marketing company) before becoming a freelance designer. Her love for food inspired her to combine her skills as a designer and artist to create the blog starvingartistbook.tumblr.com. This blog has been featured on numerous sites, such as *Tasting Table*, *Tumblr Radar*, *Cross Connect Magazine*, *Pixel Union*, and many other art blogs. Sara has been interviewed and featured in *Pink Noise*, and *BE Magazine*, and illustrated for *Amazon*, *Darling Magazine*, *Gather Journal*, *Edible Baja Arizona*, *Graze Magazine*, and *The Runcible Spoon*.

She currently works as a professional illustrator, represented by New Leaf Literary & Media, and resides on the West Coast with her husband.

INDEX